Published by **Hero Collector Books**, a division of Eaglemoss Ltd. 2019
Premier Place, 2 & A Half Devonshire Square, EC2M 4UJ, London, UK.

Second printing 2021

General Editor: Ben Robinson
Project Manager: Jo Bourne

ISBN 978-1-85875-609-7

10 9 8 7 6 5 4 3 2

Printed in China

007

50

GREATEST BOND CARS

DRIVEN BY BOND

08: ASTON MARTIN DB5

10: ASTON MARTIN V8

12: SUNBEAM ALPINE

14: MOON BUGGY

16: ASTON MARTIN DBS

18: TRIUMPH STAG

20: BENTLEY 3.5 LITRE

22: AMC HORNET

24: LOTUS ESPRIT

26: LOTUS TURBO ESPRIT

28: CITROËN 2CV

30: MERCEDES 250SE

32: RENAULT 11

34: MUSTANG MACH 1

36: BMW Z3 ROADSTER

38: BMW 750iL

40: BMW Z8

42: ASTON MARTIN V12 VANQUISH

44: ASTON MARTIN DBS

46: ASTON MARTIN DB10

DRIVEN BY BOND'S ALLIES

50: TOYOTA 2000GT

52: FORD THUNDERBIRD

54: ZAZ-965A

56: LEYLAND SHERPA VAN

58: MP LAFER

60: FORD MUSTANG

62: MERCURY COUGAR

64: LAND ROVER LIGHTWEIGHT

66: RANGE ROVER CONVERTIBLE

68: ROLLS-ROYCE SILVER CLOUD II

70: MGB

72: TUK-TUK

74: ROLLS-ROYCE SILVER SHADOW II

76: CHEVROLET CORVETTE

78: LAND ROVER DEFENDER 110

80: ASTON MARTIN DBS SUPERLEGGERA

DRIVEN BY BOND'S ENEMIES

84: ROLLS-ROYCE PHANTOM III

86: FORD FALCON RANCHERO

88: FORD COUNTRY SQUIRE

90: DRAGON TANK

92: FORD FAIRLANE

94: CADILLAC HEARSE

96: CORVORADO

98: AMC MATADOR

100: GP BEACH BUGGY

102: FERRARI F355 GTS

104: JAGUAR XKR

106: ZiL-117

108: ALFA ROMEO 159

110: JAGUAR C-X75

CONTENTS

INTRODUCTION

James Bond has driven some of the most exciting and iconic cars in movie history and he has been involved in some of the greatest car chases ever filmed. Famously, many of 007's cars have been modified by Q Branch, who fitted them with everything from machine guns to bulletproof screens, mines, lasers and ejector seats. Some of Q's cars can even turn into submarines or become invisible!

Of course, Bond has driven plenty of other cars, including classics such as the Citroën 2CV and the Triumph Stag. These cars have also been involved in incredible chases and stunts that have left the audience breathless.

Bond's enemies have also been keen to get in on the act. Goldfinger used his Rolls-Royce to smuggle gold, Scaramanga had an AMC Matador that turned into a plane, and the North Korean Zao's Jaguar was packed with as many weapons as Bond's Aston Martin.

Hundreds of extraordinary vehicles have featured on screen in Bond's adventures. On the pages that follow you will find 50 of the best, starting with the most famous Bond car of all, the Aston Martin DB5, updated for the latest Bond film *No Time To Die*.

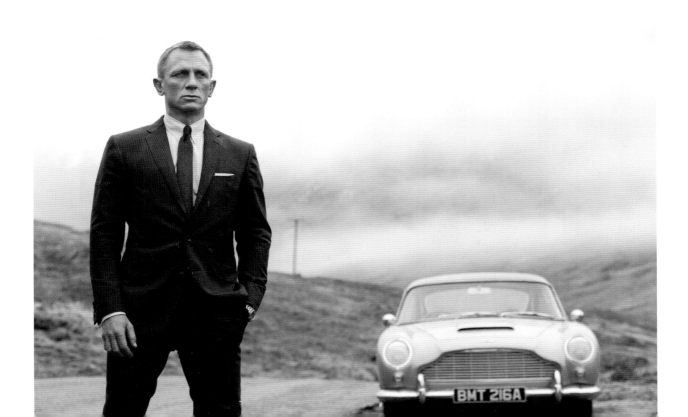

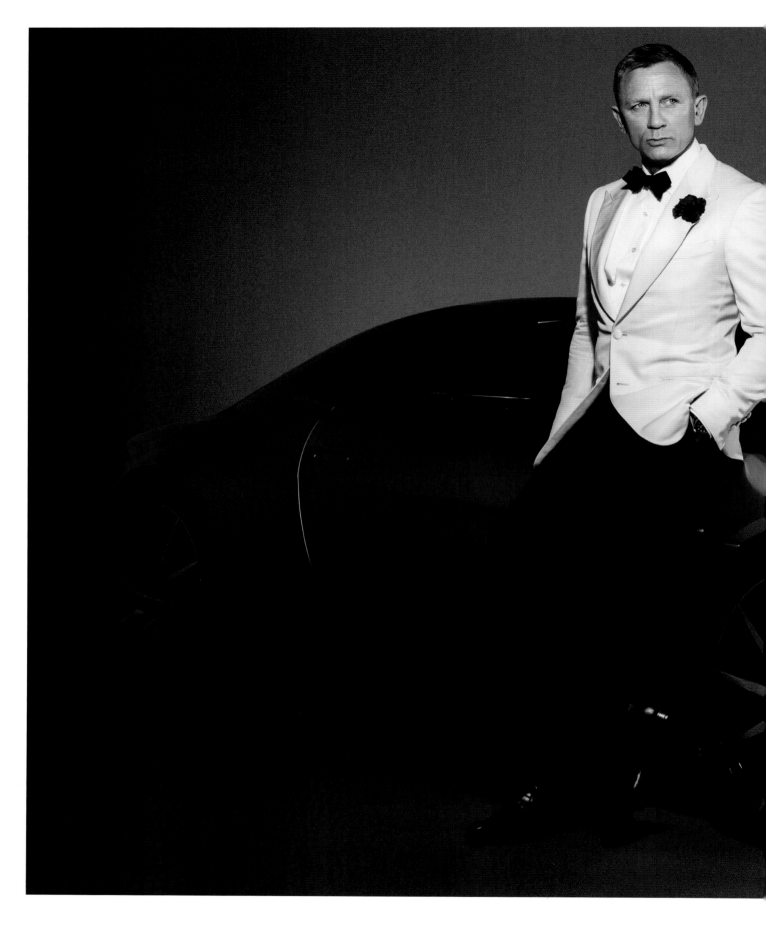

DRIVEN BY BOND

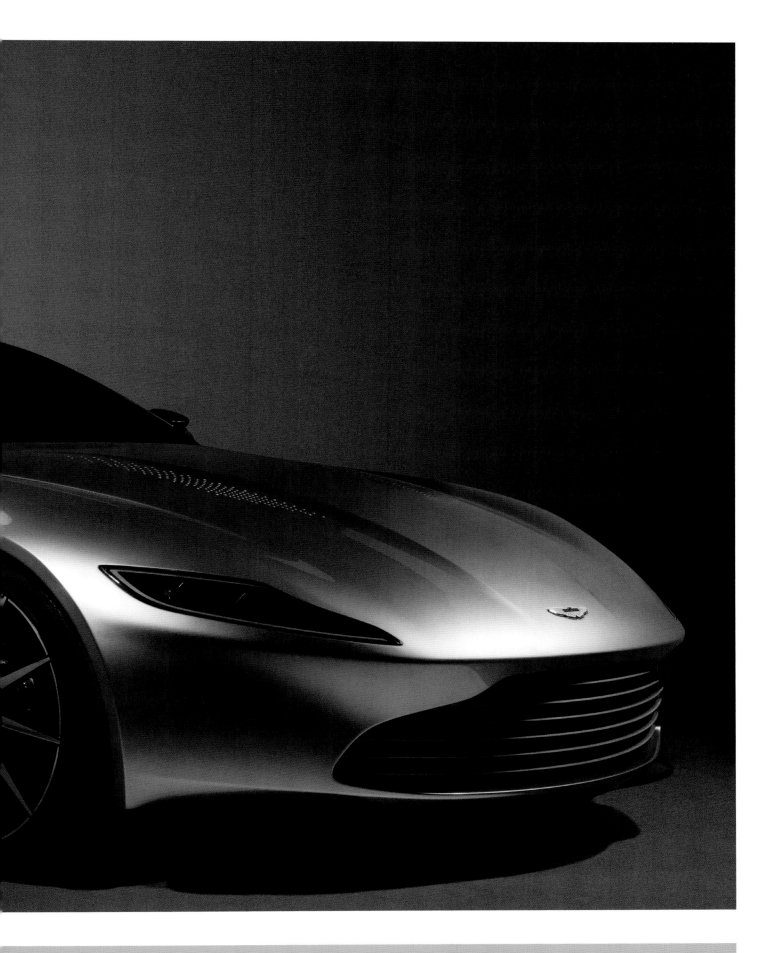

ASTON MARTIN

The Aston Martin DB5 is easily the most famous Bond car. It has appeared in eight films from *Goldfinger* to *No Time To Die*, often making use of its arsenal of hidden weapons.

SOPHISTICATED, POWERFUL AND PACKED WITH GADGETS, the Aston Martin DB5 is one of the most impressive things ever to come out of Q Branch. When it was first introduced in *Goldfinger*, it was fitted with rotating number plates, extendable overriders that can ram another car, a tracking device, a bulletproof screen, smoke canisters, tyre slashers, an oil slick, spikes for disabling pursuers, hidden machine guns and even an ejector seat. When it returned in *Thunderball*, it had gained powerful water cannons. It has been updated since then and now features upgraded machine guns and mines. *No Time To Die* is it eighth appearance, and is the fourth time that its weaponry has been shown in action.

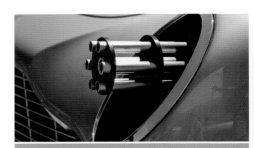

The DB5 has been given some upgrades for *No Time To Die* and now features miniguns hidden by the headlamps that fire dozens of rounds at high speed.

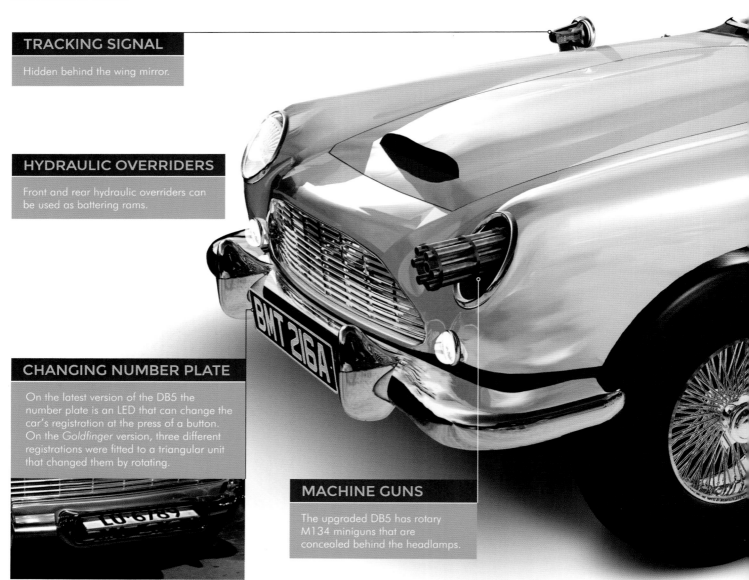

TRACKING SIGNAL

Hidden behind the wing mirror.

HYDRAULIC OVERRIDERS

Front and rear hydraulic overriders can be used as battering rams.

CHANGING NUMBER PLATE

On the latest version of the DB5 the number plate is an LED that can change the car's registration at the press of a button. On the *Goldfinger* version, three different registrations were fitted to a triangular unit that changed them by rotating.

MACHINE GUNS

The upgraded DB5 has rotary M134 miniguns that are concealed behind the headlamps.

DB5

WEAPONS TRAY

It has never been used in a film, but a tray under the driver's seat contains a folding rifle with telescopic sight, a knife, and hand grenade.

CONTROL PANEL

Controls for the defence systems are hidden in the driver's armrest, and a phone handset is built into the door. The dashboard conceals the tracking device audio-visual unit, for pinpointing the location of Q's homer device within a range of 240km.

PROTECTIVE SHIELD

A bulletproof steel plate can be raised to protect the rear window from heavy gunfire. The front windscreen and side and rear windows are bulletproof.

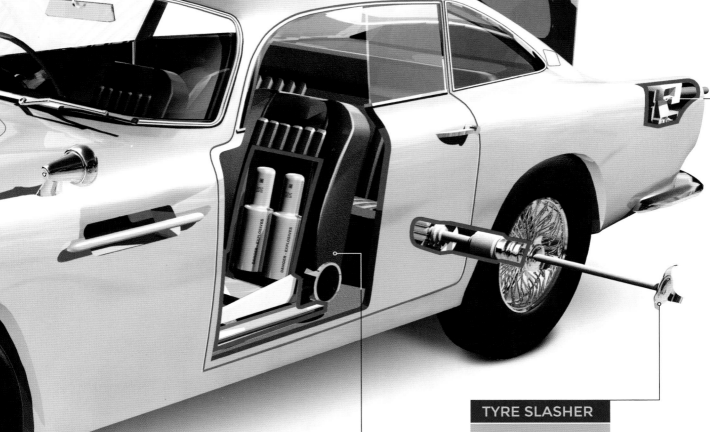

TYRE SLASHER

Blades spin outwards from the rear wheel hub, extending to 60cm.

EJECTOR SEAT

Operated by a button in the top of the gear stick, this fires an enemy passenger through a section of the roof.

REAR WEAPONS

Concealed behind the rear lights are a high-powered oil jet and a pipe that fires triple-spiked nails over the road to burst pursuing cars' tyres.

The DB5's bodywork has been reinforced to give 007 as much protection as possible from enemy gunfire.

ASTON MARTIN

The Living Daylights saw 007 driving another model made by Aston Martin, but where the DB5 had been a sporting thoroughbred, the V8 was a thoroughly modern, mean machine.

A 0–60MPH TIME OF 5.2 SECONDS and a top speed approaching 170mph made the V8 not only the UK's first true supercar, but also the fastest four-seater production car in the world when it was introduced in 1977. This Aston Martin was a perfect choice for Bond, and Q Branch upgrades such as hubcap lasers, concealed front missiles, bulletproof glass and ski outriggers help Bond and Kara Milovy escape a host of armed pursuers.

43 years after its debut and 33 years after its first appearance in a Bond movie, the V8 returns in the 2020 movie *No Time To Die*.

BULLETPROOF GLASS

The V8's bulletproof glass protects the driver from gun fire without compromising visibility – indispensable in a car chase.

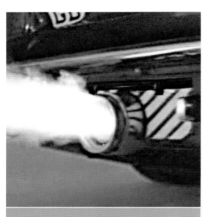

The rear number plate lifts to reveal a rocket booster, powered by a high-octane fuel source. When fired, it provides a burst of extra power and speed.

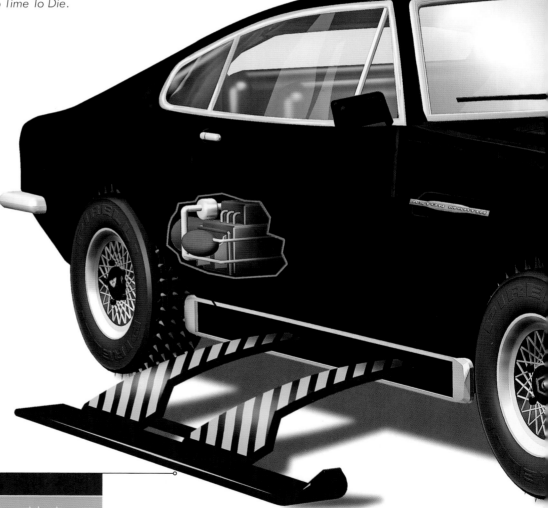

SKI OUTRIGGERS

Struts slide out from each wing of the car and the door sills flip down to create ski outriggers that guarantee speed and stability over ice and snow.

HUBCAP LASER

007's DB5 tyre slashers extend from the wheel hubs. The V8's lasers are mounted in the front wheel hubcaps, and are powerful enough to slice through the tyres and bodywork of an enemy car in seconds.

V8

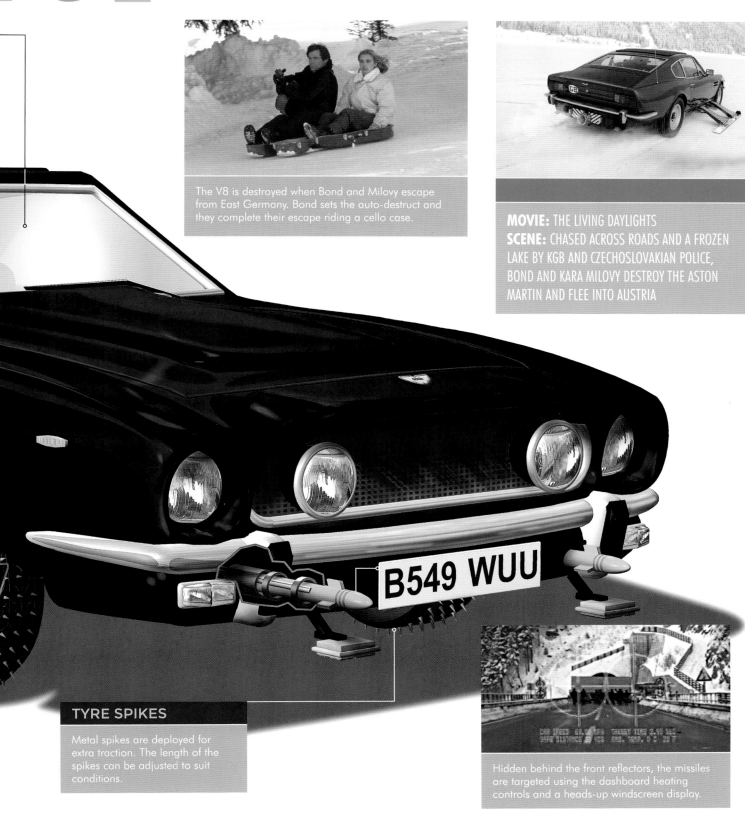

The V8 is destroyed when Bond and Milovy escape from East Germany. Bond sets the auto-destruct and they complete their escape riding a cello case.

MOVIE: THE LIVING DAYLIGHTS
SCENE: CHASED ACROSS ROADS AND A FROZEN LAKE BY KGB AND CZECHOSLOVAKIAN POLICE, BOND AND KARA MILOVY DESTROY THE ASTON MARTIN AND FLEE INTO AUSTRIA

B549 WUU

TYRE SPIKES

Metal spikes are deployed for extra traction. The length of the spikes can be adjusted to suit conditions.

Hidden behind the front reflectors, the missiles are targeted using the dashboard heating controls and a heads-up windscreen display.

SUNBEAM ALP

Bond hires a sleek Sunbeam Alpine to get around in Jamaica. What the Series II lacks in Q Branch extras, it more than makes up for in speed and sporting style.

FOR HIS FIRST cinematic car chase, 007 relies on his superior driving skills and the lively handling of his rented lake blue Series II Sunbeam Alpine convertible. Chased along Jamaica's cliff roads by Dr. No's assassins, Bond easily outdrives the 'Three Blind Mice' who are pursuing him — appropriately enough — in a hearse.

Produced by Rootes Group between 1960 and 1963, the Series II Alpine featured an enlarged engine and revised rear suspension. It was replaced by the Series III in 1963. The vehicle used in *Dr. No* was borrowed from a Jamaican resident and was one of only a few sports cars on the island.

1.6 LITRE ENGINE

The Series II engine is more powerful than its predecessor, producing 94lb/ft of torque at 3,800rpm to the original series I's 89.5lb/ft at 3,400rpm.

POWER AT IGNITION

Lightweight, cast aluminium cylinder heads give the Sunbeam a higher compression ratio than its competitors.

SHARP STYLING

The Alpine is clearly influenced by the best of American automotive design, in particular the early Ford Thunderbird.

SUNBEAM

Z 8301

MI6 sends Bond to Jamaica to investigate Dr. No, who turns out to be interfering with the American space program.

HILLMAN CHASSIS

The Sunbeam Alpine chassis is based on the Hillman Husky, a two-door estate car produced, like the Sunbeam, by the Rootes Group.

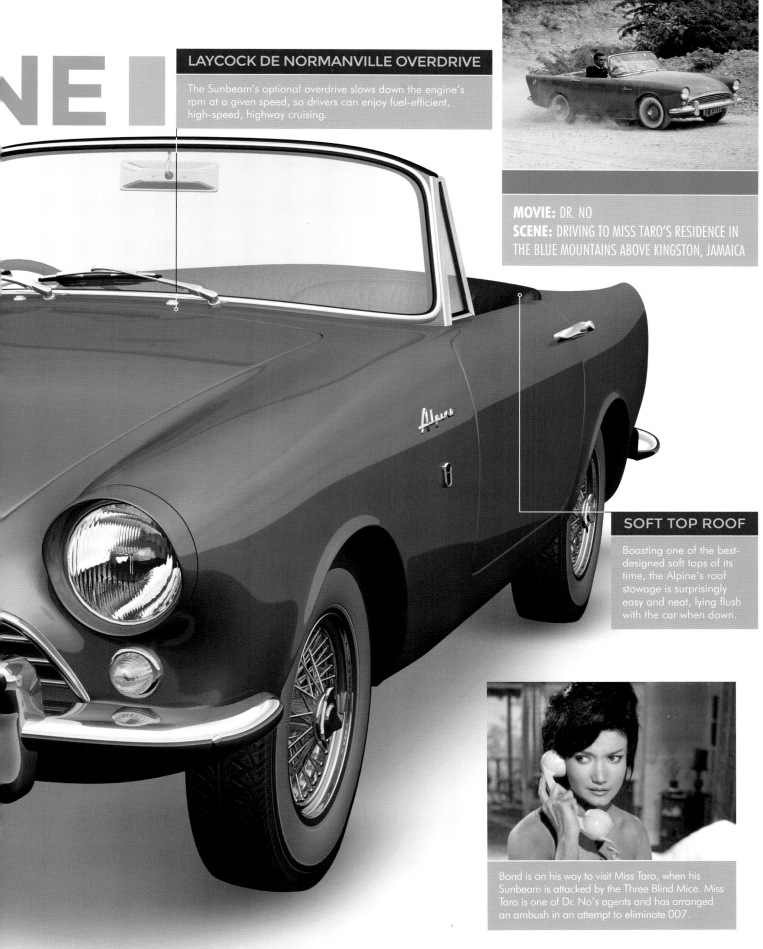

LAYCOCK DE NORMANVILLE OVERDRIVE

The Sunbeam's optional overdrive slows down the engine's rpm at a given speed, so drivers can enjoy fuel-efficient, high-speed, highway cruising.

MOVIE: DR. NO
SCENE: DRIVING TO MISS TARO'S RESIDENCE IN THE BLUE MOUNTAINS ABOVE KINGSTON, JAMAICA

Alpine

SOFT TOP ROOF

Boasting one of the best-designed soft tops of its time, the Alpine's roof stowage is surprisingly easy and neat, lying flush with the car when down.

Bond is on his way to visit Miss Taro, when his Sunbeam is attacked by the Three Blind Mice. Miss Taro is one of Dr. No's agents and has arranged an ambush in an attempt to eliminate 007.

MOON BUGGY

Bond has driven some unusual vehicles, but none more so than the moon buggy of *Diamonds Are Forever* – a machine based on the real-life lunar

WHEN 007 NEEDS to escape from Willard Whyte's research laboratory (where Blofeld's satellite is being built) across the lunar-like landscape of the Nevada desert, the Bond filmmakers took NASA's newsworthy moon buggy vehicle as their inspiration. Bond's buggy shared certain features with the real lunar rover – such as the large, all-terrain wheels – but it was built for speed and cinematic appeal.

DETACHABLE ARMS

Fitted for collecting rock and soil samples from the lunar surface, the mechanical arms enable Bond to fight off Willard Whyte's guards and punch through the factory wall at Whyte Tectronics.

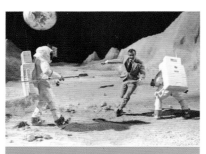

Bond discovers a lunar simulation in a restricted area of the Whyte Tectronics lab. With guards in pursuit, he climbs into the moon buggy and sets it in motion, crashing through the simulation's walls and escaping into the Nevada desert.

BATTERY POWER

The original moon buggy is battery-powered and capable of about 11mph. Bond's buggy, in contrast, can reach a more impressive 60mph.

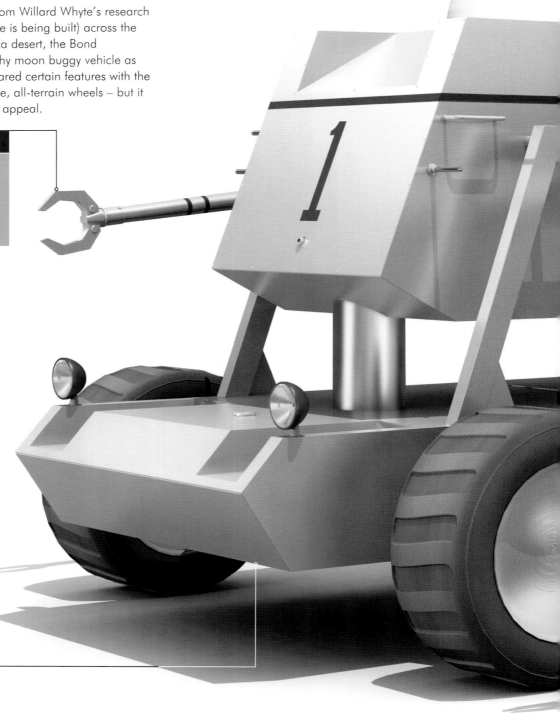

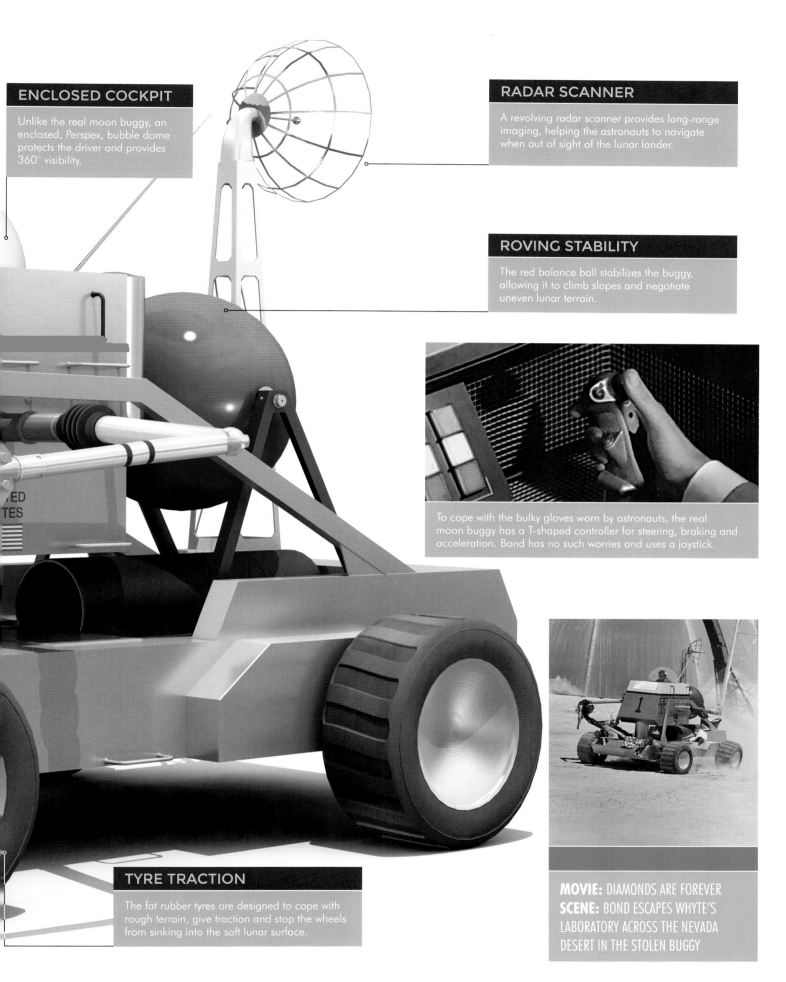

ENCLOSED COCKPIT

Unlike the real moon buggy, an enclosed, Perspex, bubble dome protects the driver and provides 360° visibility.

RADAR SCANNER

A revolving radar scanner provides long-range imaging, helping the astronauts to navigate when out of sight of the lunar lander.

ROVING STABILITY

The red balance ball stabilizes the buggy, allowing it to climb slopes and negotiate uneven lunar terrain.

To cope with the bulky gloves worn by astronauts, the real moon buggy has a T-shaped controller for steering, braking and acceleration. Bond has no such worries and uses a joystick.

TYRE TRACTION

The fat rubber tyres are designed to cope with rough terrain, give traction and stop the wheels from sinking into the soft lunar surface.

MOVIE: DIAMONDS ARE FOREVER
SCENE: BOND ESCAPES WHYTE'S LABORATORY ACROSS THE NEVADA DESERT IN THE STOLEN BUGGY

▮ASTON MARTIN

▮ Elegant and powerful, the 1968 Aston Martin DBS was the perfect car for a new Bond. Free of gadgets, it proved to be a memorable vehicle for George Lazenby's 007.

IN *ON HER MAJESTY'S SECRET SERVICE*, Bond's car returned to being just that – a car, with no additional gadgetry or weapons, except one standard sniper rifle. The DBS appears at the beginning of the film, when Bond meets his future wife Tracy, and in the film's final tragic scene, when he drives from his wedding in Portugal, only to be attacked on a coastal road by Blofeld and Irma Bunt.

Bond drives a DBS once more in *Casino Royale* (2006), a magnificent reimagining of the classic car, and *No Time To Die* (2020) features its next incredible evolution: a Superleggera.

POWERFUL ENGINE

Six-cylinder, 3,995cc engines were standard in early models. After September 1969 the DBS was available with a V8 engine, and known as the DBS V8.

QUAD HEADLIGHTS

Four distinctive quartz iodine headlights are set in a remodelled version of the iconic Aston Martin grille.

GKX 8G

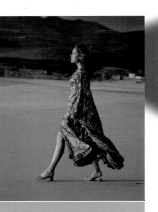

Bond is driving the DBS when he sees Tracy Di Vicenzo walking into the sea in a suicide attempt. He rescues her and the two eventually fall in love.

DE DION AXLE

The DBS chassis is based on the DB6 design, but the live axle and coil springs system was replaced by an independent, coil-sprung de Dion tube rear axle, to improve traction on rough surfaces.

DBS

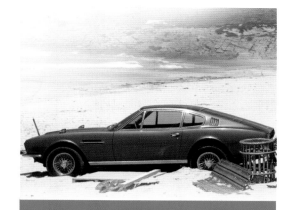

BODYWORK

Wedge-shaped styling by Aston's designer William Towns departs from the traditional curved look of previous DB cars. It also increases the luggage space.

WIRE WHEELS

Chrome wire wheels feature on the early models. From 1969, DBS V8s had lightweight alloy wheels with ventilated brake discs, seen for the first time on an Aston Martin car.

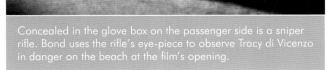

Concealed in the glove box on the passenger side is a sniper rifle. Bond uses the rifle's eye-piece to observe Tracy di Vicenzo in danger on the beach at the film's opening.

TRIUMPH STAG

Going undercover as diamond smuggler Peter Franks, 007 commandeers his criminal alter ego's Triumph Stag to drive to Tiffany Case's apartment in Amsterdam.

IN *DIAMONDS ARE FOREVER*, Bond drives to Amsterdam in Franks' convertible Triumph Stag to meet the diamond smuggler's contact, Tiffany Case. Designed to follow in the tradition of the grand tourers of the past, the Stag was glamorous, fast and comfortable.

At Dover, MI6 agents, including Moneypenny posing as a customs officer, enable Bond to make the identity switch. Bond asks Moneypenny what gift she would like from Holland, to which she wistfully replies, 'A diamond – in a ring?'

TRIUMPH V8 ENGINE

Fast and powerful, the 2,977cc engine is celebrated for its 115mph top speed and a satisfyingly sporty growl. However, the engine is also notoriously prone to overheating and expensive failures.

ITALIAN STYLING

The Stag was based on the Triumph 2000. Italian designer Giovanni Michelotti shortened the body, removed the roof and gave the Stag new and sharper lines.

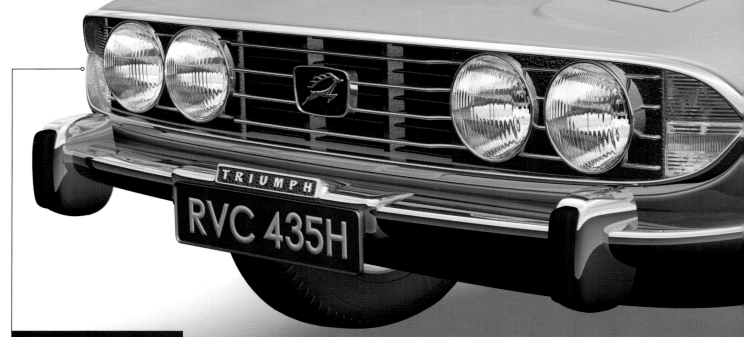

FRONT GRILLE

The Stag showcased the new 'face' of Triumph. Quad headlights are housed on the simplified four-bar grille.

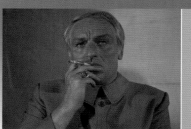

Blofeld needs diamonds to build a powerful laser mounted on a satellite. His plan is to use the laser to threaten Earth's nuclear weapons.

OVERHEAD T-BAR

To improve the rigidity of the car and meet US rollover constraints, the Stag features a B-pillar rollbar and a T-bar to connect the rollbar to the windscreen.

FOUR SEATER

The Stag boasts an undeniable advantage over its sports car rivals: it has four seats rather than the usual two.

The Triumph Stag originally belonged to Peter Franks, who Bond kills in a vicious fight in Amsterdam.

MOVIE: DIAMONDS ARE FOREVER
SCENE: TRAVELLING TO AMSTERDAM

BENTLEY 3.5 LIT

Bond's first car is a graceful Bentley 3.5 litre in British Racing Green, appearing in the early scenes of *From Russia With Love*. Built at the Rolls-Royce factory, the car epitomized quality and style.

BOND IS ENJOYING a day out with Sylvia Trench on a secluded part of a river when he is paged by MI6 headquarters. Returning to his Bentley parked nearby, Bond uses the mobile telephone system (MTS) installed on the wooden dashboard to ring Moneypenny. She informs him that M has been looking for him all morning and he needs to report in.

Presented to the public in 1933, this vehicle was already 30 years old and therefore a classic by the time it appeared in *From Russia With Love*. It was an ode to Bond's first car in Ian Fleming's novels – a 1930 Bentley 4.5 litre.

YFF 417

DASHING AND DAPPER

The long wheelbase and large wheels make for a smooth ride, but its light weight also give it nimble cornering.

SIGNATURE STYLE

The Bentley spirit is exemplified by the chrome radiator grille and huge headlights. The radiator shape and badge were the only parts of the car carried over from earlier Bentleys before Rolls-Royce took over.

DROPHEAD ROOF

The car can be driven with the roof closed, with just the front rolled back, or in complete convertible mode. Raising and lowering the roof had to be done manually.

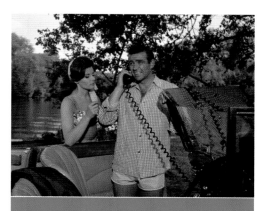

MOVIE: FROM RUSSIA WITH LOVE
SCENE: BOND TAKES SYLVIA TRENCH TO A RIVERSIDE SPOT FOR A PICNIC

BESPOKE BODYWORK

Bentley built the engine, chassis, radiator and bonnet, but the bodywork was made and fitted by the customer's choice of coachbuilder.

STOPPING POWER

The brakes are servo-assisted, and fitted to all four wheels. Rolls-Royce had acquired them under licence from another luxury car manufacturer, Hispano-Suiza.

SILENT BUT STRONG

The later Bentley 4.25 litre became known as 'The Silent Sports Car' because the engine was so quiet while managing to maintain the high-performance aspect for which the 3.5 Bentleys were so famous.

M summons Bond to send him to Istanbul, where MI6 believe a Soviet agent called Tatiana Romanova will help him acquire an encoding device called the Lecter.

AMC HORNET

The Hornet won fame thanks to one of the most impressive stunts seen in the Bond franchise, which also set a world record for the first Astro-Spiral Jump on film.

IN *THE MAN WITH THE GOLDEN GUN*, Bond commandeers a Hornet X hatchback coupé from an AMC dealership in Bangkok to pursue Scaramanga through the city streets and into the countryside. To traverse a river, Bond guns the engine and accelerates up part of a fallen bridge to perform a spectacular 360° mid-air roll.

The leap was performed in a picture-perfect single take by stunt driver Loren 'Bumps' Willert, and the Hornet's appearance in the film transformed its image from family car to 1970s stunt legend.

RACING STYLE

Trimmed with styled wheels, fat tyres and go-faster stripes along the sides, the Hornet X hatchback coupé has a sportier look than the standard saloon.

HOT HATCH

Introduced in 1973, when hatchbacks were relatively new in the US, the Hornet beats its contemporaries on looks. *Car and Driver* called it 'The styling coup of '73'.

Bond uses the Hornet when he is tracking Scaramanga, an assassin who is obsessed with testing himself against the very best.

FLEXIBLE BOOT SPACE

The open boot can be converted into a camper using an AMC vinyl cover with mosquito netting. With the back seat down, the Hornet boot is large enough to sleep two.

SIDEBARS

The Hornet is the first car to feature side-impact bars, or as AMC called them, 'internally reinforced guard rail beams'.

EXTRA LEG ROOM

The Hornet hatchback has the classic 1970s long hood/short deck shape seen on pony cars like the Ford Mustang. Built on the same 274cm chassis as the saloon model, it boasts more interior space than most.

Sheriff J.W. Pepper is on holiday in Bangkok and about to test drive the Hornet, when Bond gets in beside him and chases Scaramanga. The two men had previously met in Louisiana.

MOVIE: THE MAN WITH THE GOLDEN GUN
SCENE: BOND PURSUES SCARAMANGA THROUGH THE STREETS OF BANGKOK AND ACROSS A RIVER

SAFETY FIRST

The grille, bonnet and front bumpers have evolved by 1974 to blend together smoothly. Bumpers are engineered to be energy-absorbing and pop back into place after a low-speed impact.

AMC

LOTUS ESPRIT

Q Branch proves appearances can be deceptive with its unique Lotus Esprit. This high-performance sports car transforms into a submarine, fully equipped with an impressive array of underwater weaponry.

AUDIENCES WATCHING *THE SPY WHO LOVED ME* are amazed when Bond drives his Esprit off a jetty and into the sea. But what happens next is more remarkable still: the Esprit transforms into a submarine. Nicknamed 'Wet Nellie', the Lotus is made of waterproof, lightweight fibreglass. It can dive to 100 metres and remain submerged for up to two hours. 007 then tests the Esprit's weaponry in an underwater battle with Karl Stromberg's frogmen.

TELESCOPIC PERISCOPE

The periscope provides a 360° field of vision for the pilot to locate enemy craft and divers.

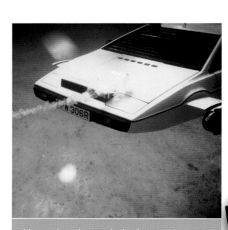

Housed underneath the bonnet are two harpoon guns and a powerful battery of four heat-seeking missile launchers. Two missiles contain stun grenades and the other two, explosive warheads.

In underwater mode, the Esprit's dual-purpose dashboard revolves to reveal a nautical control panel with a navigation system.

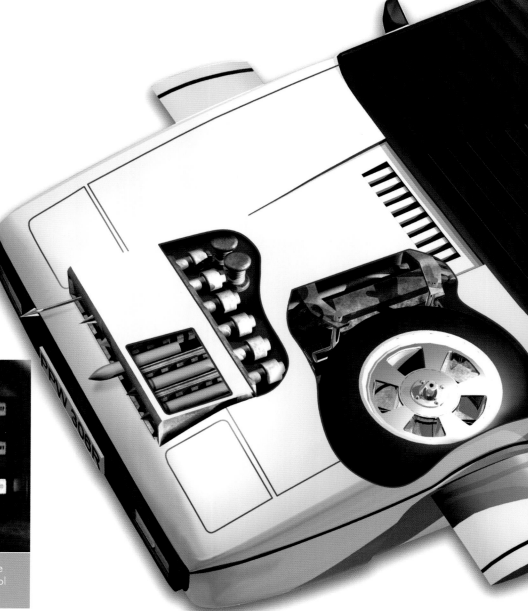

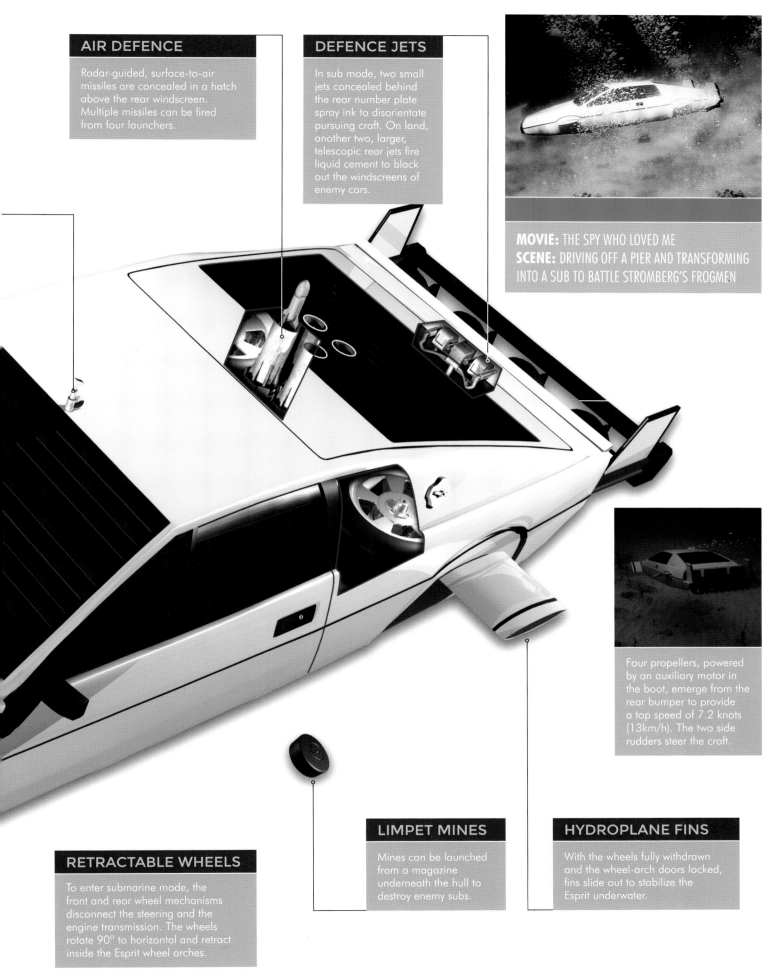

AIR DEFENCE

Radar-guided, surface-to-air missiles are concealed in a hatch above the rear windscreen. Multiple missiles can be fired from four launchers.

DEFENCE JETS

In sub mode, two small jets concealed behind the rear number plate spray ink to disorientate pursuing craft. On land, another two, larger, telescopic rear jets fire liquid cement to black out the windscreens of enemy cars.

MOVIE: THE SPY WHO LOVED ME
SCENE: DRIVING OFF A PIER AND TRANSFORMING INTO A SUB TO BATTLE STROMBERG'S FROGMEN

Four propellers, powered by an auxiliary motor in the boot, emerge from the rear bumper to provide a top speed of 7.2 knots (13km/h). The two side rudders steer the craft.

RETRACTABLE WHEELS

To enter submarine mode, the front and rear wheel mechanisms disconnect the steering and the engine transmission. The wheels rotate 90° to horizontal and retract inside the Esprit wheel arches.

LIMPET MINES

Mines can be launched from a magazine underneath the hull to destroy enemy subs.

HYDROPLANE FINS

With the wheels fully withdrawn and the wheel-arch doors locked, fins slide out to stabilize the Esprit underwater.

LOTUS TURBO E

The Lotus Turbo Esprit may be lighter on gadgetry than its submersible predecessor, the Lotus Esprit, but it is more than a match for elegance and sheer power on the road.

FOR YOUR EYES ONLY sees 007 drive a beautiful British sports car, the Lotus Turbo Esprit. In fact, Bond gets two of these supercars: one white and one in 'Copper Fire'. Unlike his submarine Lotus in *The Spy Who Loved Me*, 007 relies more on the Turbo Esprit's speed and renowned handling than on any Q Branch modifications. However, the car is not entirely without weapons, and the white Lotus's extreme anti-theft device takes out at least one of Gonzales' henchmen.

Lotus debuted the Turbo Esprit in 1981 along with their Series 3 Esprit, inheriting aerodynamics from the Esprit and featuring prominent decals.

AIR CHANNELS

Air ducts placed in the side skirts and two 'ears' at the back of the rear windows provided extra cooling for the Turbo Esprit engine compartment.

TURBO-CHARGED ENGINE

The new Lotus 2.2 turbo engine was more powerful than its Esprit predecessor. It produced 200lb/ft of torque at 4,500rpm. Accelerating from 0 to 150mph (240km/h) in just 15 seconds, it was one of the fastest accelerating road cars of its day.

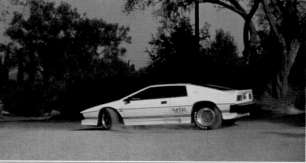

The Turbo Esprit was the first Bond car fitted with a Q Branch self-destruct system, designed to protect MI6 secrets from enemy agents. Vibration sensors triggered four 500g packs of C4 explosives hidden on both sides of the car, front and back. When Gonzales' henchman attempted to break in to 007's white Turbo Esprit with a gun, he activated the extreme burglar alarm.

SPRIT

CUSTOM-MADE SKI RACKS

Q Branch winterized the Turbo Esprit with ski racks on the roof. It provides the perfect cover for Bond when he visits the Italian ski resort, Cortina d'Ampezzo.

MAGNETIC SEALS

An extra anti-theft protection device, magnetic seals on the doors and the boot made it almost impossible to break into the Turbo.

MOVIE: FOR YOUR EYES ONLY
SCENE: THE WHITE ESPRIT IS BLOWN UP WITH ITS SELF-DESTRUCT SYSTEM IN SPAIN, WHILE THE COPPER FIRE REPLACEMENT IS USED BY BOND TO TRAVEL TO THE MOUNTAINS OF CORTINA

FIBREGLASS BODY

Like Lotus's F1 racers, the Turbo Esprit had a reinforced fibreglass body mounted on a galvanized zinc backbone chassis. This protected the car from rust and reduced weight, which helped make the Turbo the fastest production car manufactured by Lotus.

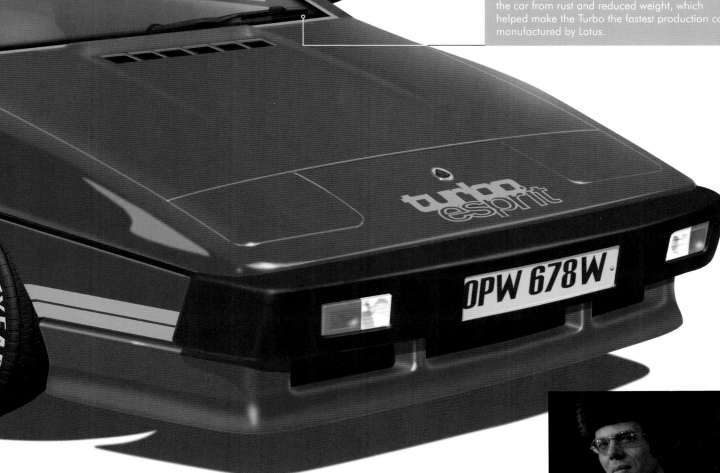

Bond takes his second Lotus Turbo to Italy where he is tracking the villainous Emile Locque.

CITROËN 2CV

Perhaps the most surprising of 007's automobiles, a borrowed 2CV is able to get James Bond out of trouble without the aid of high-tech gadgets thanks to his impressive driving.

THE CAR NICKNAMED the 'tin snail' proves its worth in *For Your Eyes Only* when 007 drives Melina Havelock's 2CV through steep olive groves to escape Gonzales' henchmen, after Melina has killed Gonzales at his Spanish villa.

Described by its creator as 'four wheels under an umbrella', the 2CV is neither the most glamorous nor at the cutting edge of Bond's many vehicles. However, when introduced at the Paris Motor Show in 1948, the 2CV boasted an extraordinary level of technology for the time, and during 42 years of production, Citroën made very few major mechanical changes.

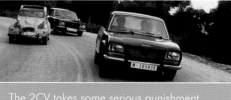

The 2CV takes some serious punishment when Bond and Melina are chased along mountain roads in Spain.

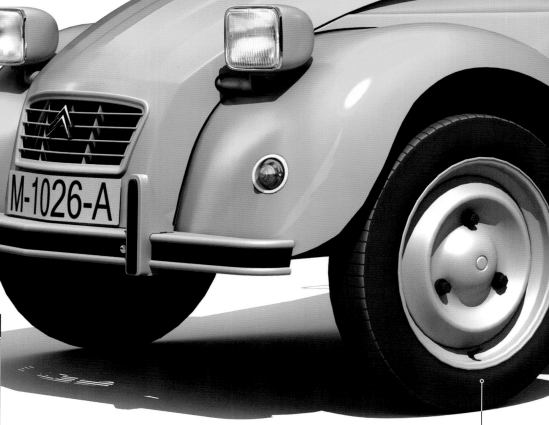

M-1026-A

FRONT-WHEEL DRIVE

The 2CV was the first low-cost car to use front-wheel drive, pioneered by Citroën on the 1934 Traction Avant. This made the 2CV easier to handle and safer than many of its contemporaries.

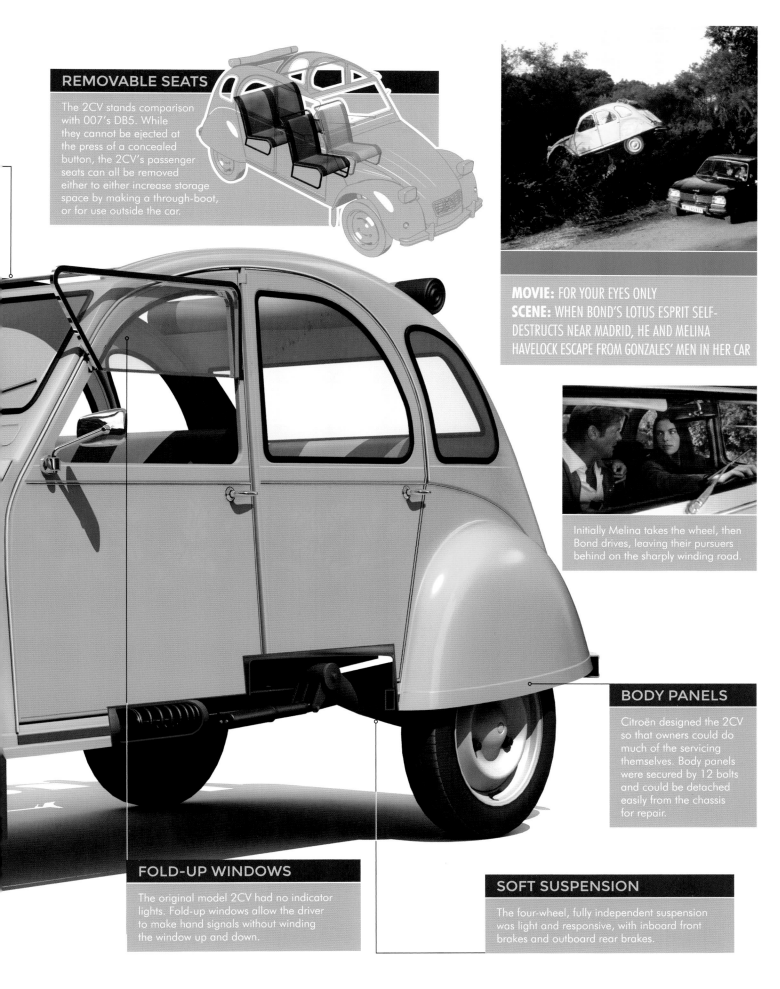

REMOVABLE SEATS

The 2CV stands comparison with 007's DB5. While they cannot be ejected at the press of a concealed button, the 2CV's passenger seats can all be removed either to either increase storage space by making a through-boot, or for use outside the car.

MOVIE: FOR YOUR EYES ONLY
SCENE: WHEN BOND'S LOTUS ESPRIT SELF-DESTRUCTS NEAR MADRID, HE AND MELINA HAVELOCK ESCAPE FROM GONZALES' MEN IN HER CAR

Initially Melina takes the wheel, then Bond drives, leaving their pursuers behind on the sharply winding road.

BODY PANELS

Citroën designed the 2CV so that owners could do much of the servicing themselves. Body panels were secured by 12 bolts and could be detached easily from the chassis for repair.

FOLD-UP WINDOWS

The original model 2CV had no indicator lights. Fold-up windows allow the driver to make hand signals without winding the window up and down.

SOFT SUSPENSION

The four-wheel, fully independent suspension was light and responsive, with inboard front brakes and outboard rear brakes.

MERCEDES 250S

> Despite losing all four tyres, neither Bond nor the Mercedes 250SE are fazed. Chasing down the railway track on just its rims, the German saloon car proves itself an adaptable performer.

BY 1983, GENERAL ORLOV'S stately Mercedes 250SE limousine was more than a decade old, but a class act. Only James Bond could treat this deluxe saloon car with such irreverence. With the tyres shredded by gunfire, Bond drives his Mercedes onto the railway tracks to pursue General Orlov's nuclear bomb. Just after 007 leaps from the car to the train, this classic of German engineering comes to an end when struck by an oncoming locomotive, landing in a lake.

The 250SE was the work of legendary French auto designer Paul Bracq. His other credits include the Mercedes 230SL Pagode and the BMW Turbo concept car.

FUEL INJECTION

Mercedes was one of the first automakers to fit a fuel injection system into a petrol car. The 250SE's 6-cylinder engine has a fuel injection pump producing an impressive 150bhp at 5,500rpm.

RUSSIAN INSIGNIA

The 250SE bears a Russian military-style emblem to identify it as General Orlov's car.

TRADEMARK GRILLE

The 250SE is one of the last models to bear the instantly recognizable upright front grille. Future generations of Mercedes would become flatter and wider at the front.

BT 36-72

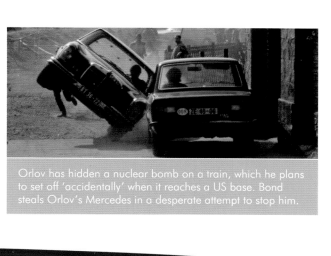

Orlov has hidden a nuclear bomb on a train, which he plans to set off 'accidentally' when it reaches a US base. Bond steals Orlov's Mercedes in a desperate attempt to stop him.

MOVIE: OCTOPUSSY
DRIVEN BY: ORLOV'S CHAUFFEUR & BOND
SCENE: BOND PURSUES THE CIRCUS TRAIN THAT IS PLANTED WITH A BOMB

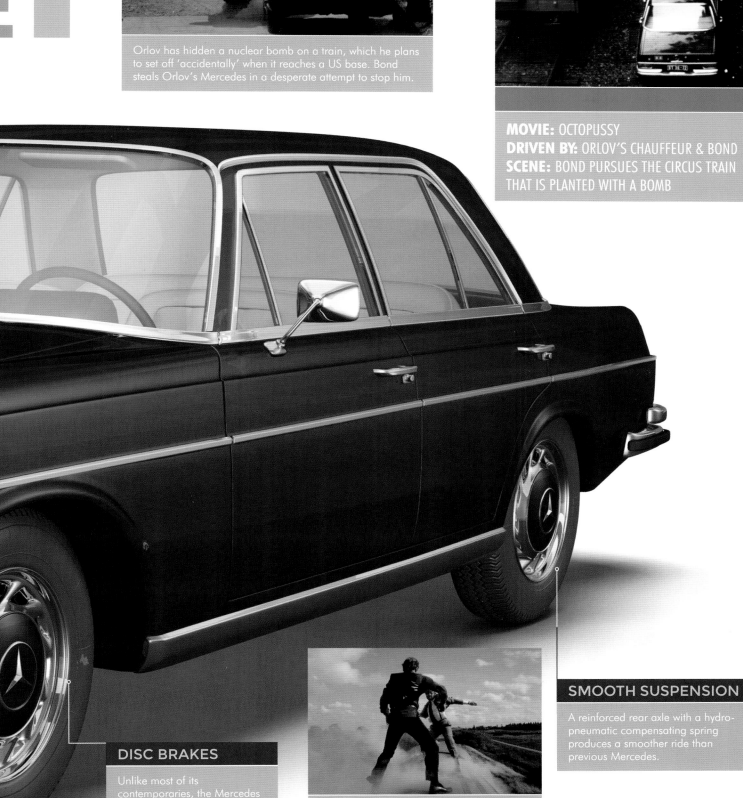

SMOOTH SUSPENSION

A reinforced rear axle with a hydro-pneumatic compensating spring produces a smoother ride than previous Mercedes.

DISC BRAKES

Unlike most of its contemporaries, the Mercedes has all round disc brakes for improved stopping power.

Bond jumps from the car to the train, where he fights Gobinda but cannot stop the bomb reaching its destination.

▌RENAULT 11 ▌

▌ Bond pursues May Day through the centre of Paris in a Renault 11 taxi. The vehicle proves remarkably resilient, surviving a series of spectacular collisions, until it is finally split in two.

AS MAY DAY PARACHUTES off the Eiffel Tower, 007 grabs the Renault 11 and gives chase. He smashes into souvenir stands and skids down steps. Forced up a ramp, the Renault lands on top of a bus, before a barrier tears the car's roof off. Stunt driver Rémy Julienne performed this scene – on which the timing was 'terrifying' – and arranged the sequence. The taxi only comes to a halt when it loses its rear end in a final collision.

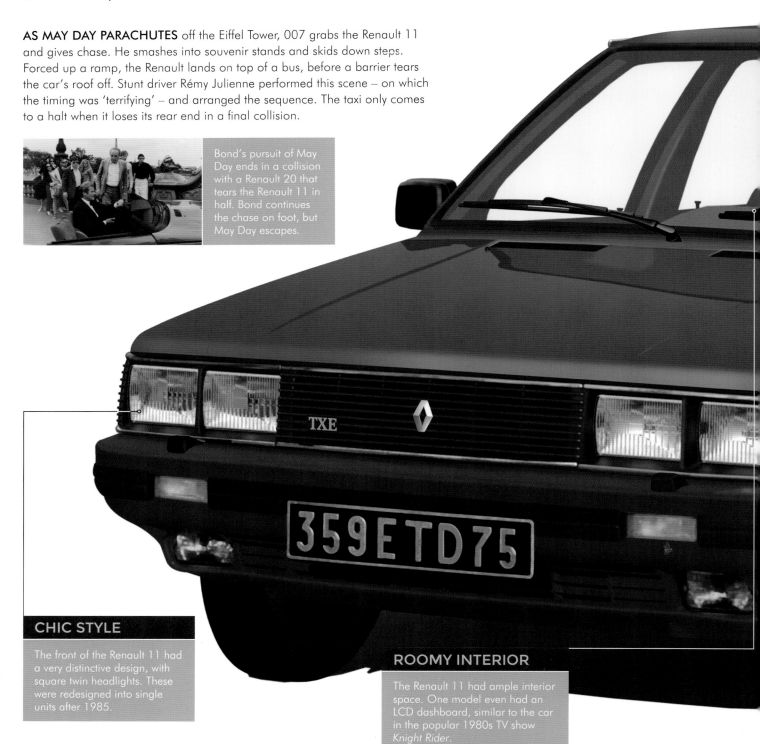

Bond's pursuit of May Day ends in a collision with a Renault 20 that tears the Renault 11 in half. Bond continues the chase on foot, but May Day escapes.

CHIC STYLE

The front of the Renault 11 had a very distinctive design, with square twin headlights. These were redesigned into single units after 1985.

ROOMY INTERIOR

The Renault 11 had ample interior space. One model even had an LCD dashboard, similar to the car in the popular 1980s TV show *Knight Rider*.

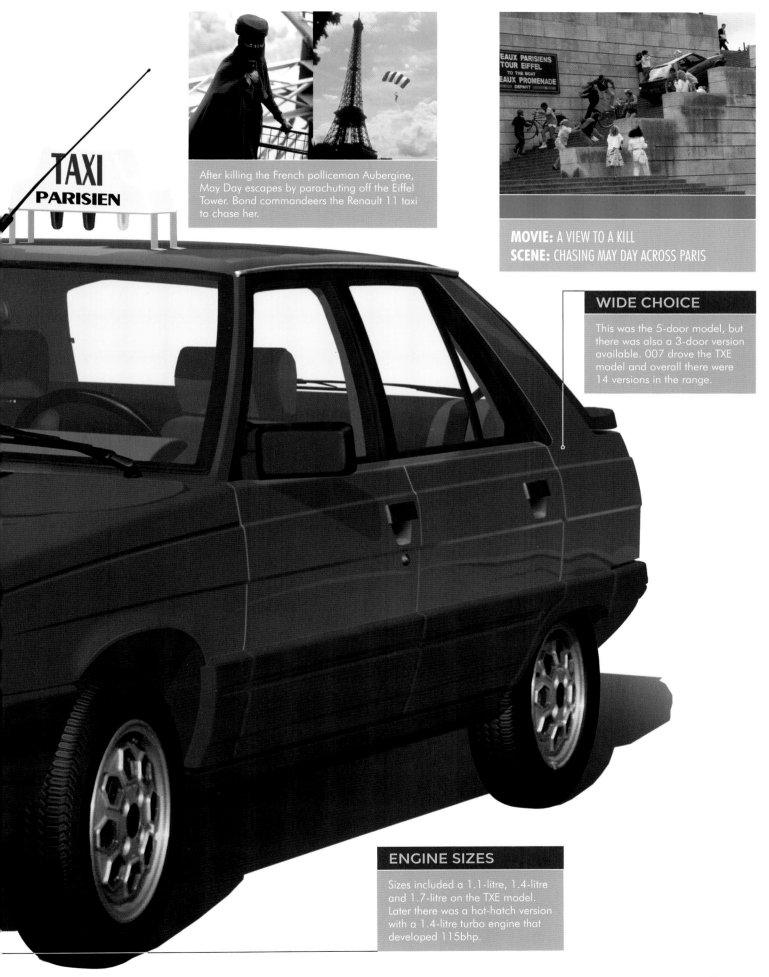

After killing the French policeman Aubergine, May Day escapes by parachuting off the Eiffel Tower. Bond commandeers the Renault 11 taxi to chase her.

MOVIE: A VIEW TO A KILL
SCENE: CHASING MAY DAY ACROSS PARIS

WIDE CHOICE

This was the 5-door model, but there was also a 3-door version available. 007 drove the TXE model and overall there were 14 versions in the range.

TAXI
PARISIEN

ENGINE SIZES

Sizes included a 1.1-litre, 1.4-litre and 1.7-litre on the TXE model. Later there was a hot-hatch version with a 1.4-litre turbo engine that developed 115bhp.

MUSTANG MACH

Diamonds Are Forever sees 007 on the trail of villains in Las Vegas – who attempt to have him arrested. He drives his way out of trouble in Tiffany Case's powerful Mustang.

WITH THE LAS VEGAS police department on his tail, Bond puts Tiffany Case's Mustang Mach 1 through its paces. In his bid to evade his pursuers, Bond uses the Mustang to jump over parked cars, and even balances the car on two wheels, allowing it to slip through a narrow alleyway.

The distinctive throaty roar as 007 revs up the Mach 1 gives a clue to the impressive 7-litre Ford engine beneath the bonnet. It's the Mustang's specially stiffened suspension that allows Bond to turn the car on its side.

429 COBRA JET ENGINE

The 7-litre 'big block' engine makes the Mustang an all-American muscle car. In the late 1960s, big blocks were fitted to small cars to provide extra horsepower and torque – in this case a mighty 370bhp and 450lbf-ft.

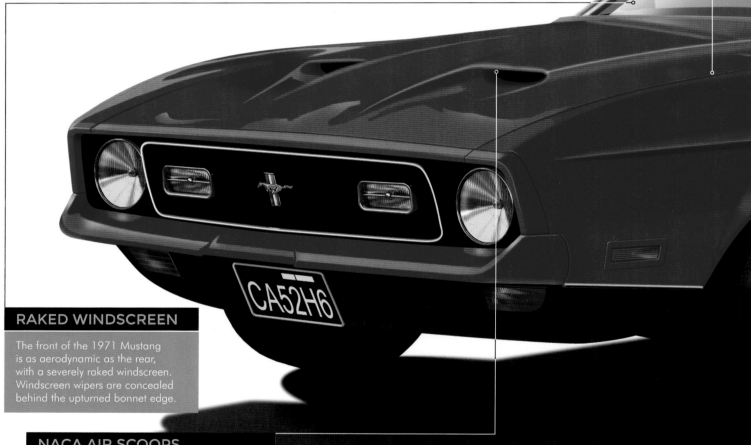

RAKED WINDSCREEN

The front of the 1971 Mustang is as aerodynamic as the rear, with a severely raked windscreen. Windscreen wipers are concealed behind the upturned bonnet edge.

NACA AIR SCOOPS

Originally designed by the National Advisory Committee for Aeronautics – which later became NASA – these air intakes are seen on racing cars. The flush inlets reduce drag and disturb airflow less than protruding scoops.

After Bond's breakout from Whyte Tectronics, he escapes with Tiffany in her Mustang. But the Las Vegas sheriff has been tipped off about the 'saboteur' and a police chase is on...

FASTBACK REAR

The Mach 1's fastback styling is the work of legendary car designer Larry Shinoda, who also worked on the Corvette Sting Ray. The fastback is aerodynamic and gives the Mach 1 its famous 'slippery' look.

MOVIE: DIAMONDS ARE FOREVER
DRIVEN BY: JAMES BOND
SCENE: BOND AND TIFFANY ARE PURSUED THROUGH THE STREETS BY THE LAS VEGAS POLICE

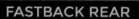

mach 1
MUSTANG

The Mustang belongs to Tiffany Case, a diamond smuggler whom Bond is investigating. She is unaware that she is working for Blofeld.

COMPETITION SUSPENSION

The 1971 Mach 1 Mustang comes with tuned suspension. High-rate springs, shocks and stabilizer bars make it stiffer at speed.

BMW Z3 ROADST

GoldenEye is the first film in which Bond drives a BMW. Q Branch have once again excelled by turning the sleek, retro-styled roadster into a mobile arsenal.

GOLDENEYE MARKED A NEW beginning for the Bond series, and a new 007 required a new car. Pierce Brosnan's Bond drives a stylish BMW Z3 Roadster. Though the Z3 is fitted with an array of Q Branch refinements, in this mission they stay under wraps. 'Need I remind you, 007, that you have a licence to kill, not to break the traffic laws,' advises Q.

Introduced in 1996, shortly after appearing in *GoldenEye*, the first year's production run of about 15,000 sold out before its release and 100 exclusive James Bond Edition Z3s were also created and sold.

SELF-DESTRUCT SYSTEM

The Z3 features an updated version of the self-destruct systems seen on the 1980 Lotus Turbo Esprit and Bond's 1987 Aston Martin V8. It can be activated to prevent Q Branch secrets falling into enemy hands.

STINGER MISSILES

Stinger missiles are concealed behind the headlights. Directed by a fire-and-forget passive infrared seeker guidance system and fitted with high-explosive warheads, the missiles have an effective range of up to 8km.

ER

Bond's Russian ally Natalya jokes that he destroys every vehicle he gets in, but the Z3 survives its trip to Cuba unscathed.

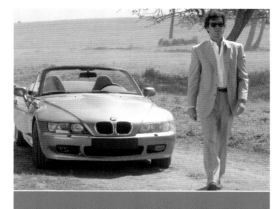

MOVIE: GOLDENEYE
SCENE: DRIVEN BY 007 BRIEFLY IN CUBA BEFORE HE TRADES IT FOR JACK WADE'S PLANE

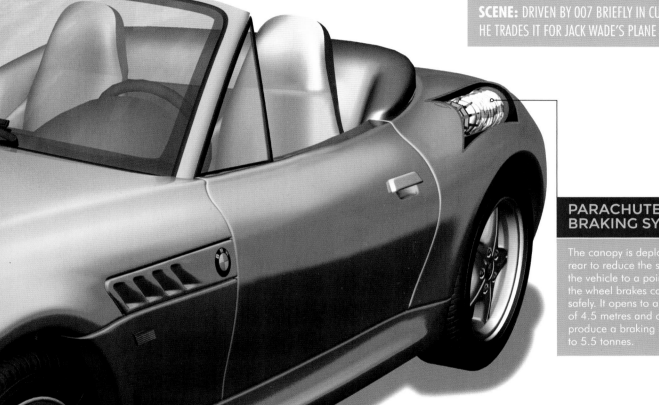

PARACHUTE BRAKING SYSTEM

The canopy is deployed at the rear to reduce the speed of the vehicle to a point where the wheel brakes can be used safely. It opens to a diameter of 4.5 metres and can produce a braking force of up to 5.5 tonnes.

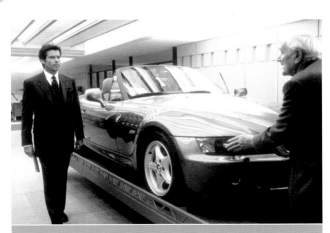

Q introduces Bond to the BMW at MI6 headquarters in London, and later on it is shipped out to Cuba.

▮BMW 750iL▮

Q gives Bond the BMW flagship model 750iL at an Avis car rental in Germany. Bond duly returns it, but only after making full use of its Q Branch 'extras'.

ROCKET ARRAY

Hidden in the sun roof is a rocket array capable of firing up to 12 surface-to-surface (STS) missiles.

ON ASSIGNMENT IN HAMBURG, Bond poses as a banker, complete with a top-of-the-range BMW 7 series. Not only is it ideal for his cover, it has enough room to house an arsenal of weapons and defence systems, which Bond uses during an intense chase through the Atlantic Hotel parking garage. Best of all, unlike 007's usual sports cars, the spacious four-seater 750iL allows Bond to perform some incredible back-seat driving, controlling the vehicle from his Q-adapted Ericsson cell phone.

Underneath its executive exterior, this BMW packs 322 bhp and a top speed of 155mph (249km/h).

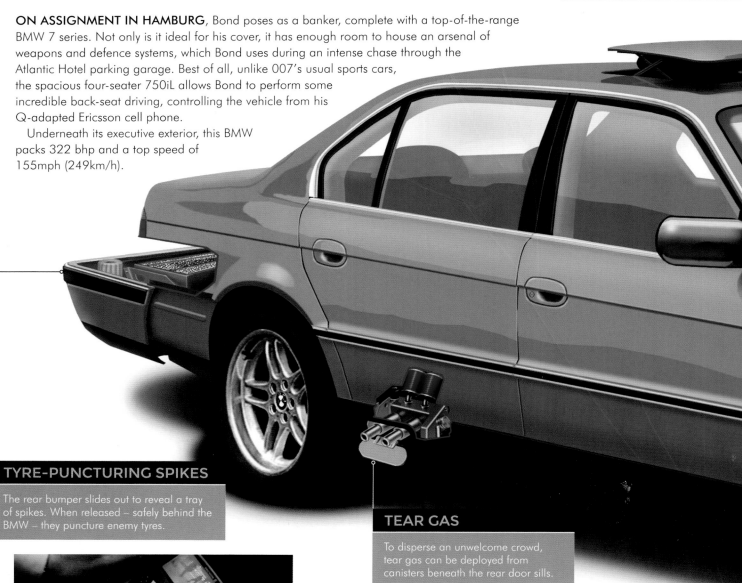

TYRE-PUNCTURING SPIKES

The rear bumper slides out to reveal a tray of spikes. When released – safely behind the BMW – they puncture enemy tyres.

When Carver's operatives attack Bond, he uses his phone to control the 750iL remotely. First, he drives to his location and then jumps into the back seat.

TEAR GAS

To disperse an unwelcome crowd, tear gas can be deployed from canisters beneath the rear door sills.

BURGLAR DETERRENT

This electrifies the entire car. Anyone tampering with the bodywork suffers a 20,000-volt electric shock.

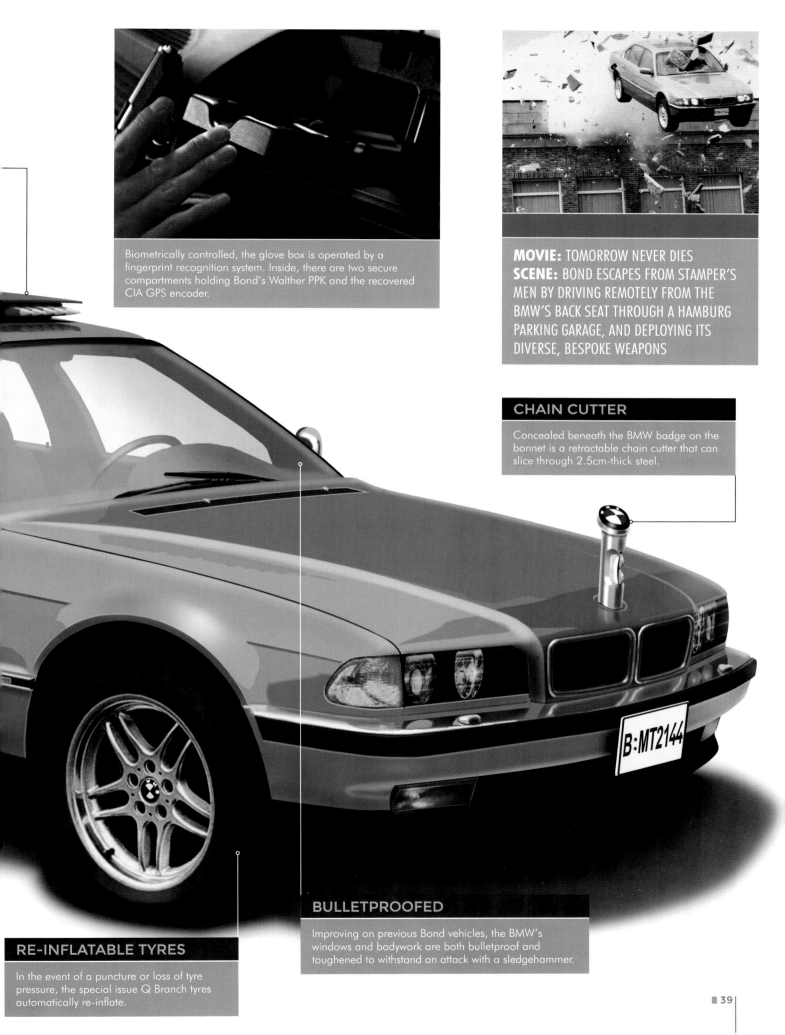

Biometrically controlled, the glove box is operated by a fingerprint recognition system. Inside, there are two secure compartments holding Bond's Walther PPK and the recovered CIA GPS encoder.

MOVIE: TOMORROW NEVER DIES
SCENE: BOND ESCAPES FROM STAMPER'S MEN BY DRIVING REMOTELY FROM THE BMW'S BACK SEAT THROUGH A HAMBURG PARKING GARAGE, AND DEPLOYING ITS DIVERSE, BESPOKE WEAPONS

CHAIN CUTTER

Concealed beneath the BMW badge on the bonnet is a retractable chain cutter that can slice through 2.5cm-thick steel.

RE-INFLATABLE TYRES

In the event of a puncture or loss of tyre pressure, the special issue Q Branch tyres automatically re-inflate.

BULLETPROOFED

Improving on previous Bond vehicles, the BMW's windows and bodywork are both bulletproof and toughened to withstand an attack with a sledgehammer.

BMW Z8

Bond's Z8 roadster in *The World is Not Enough* is his third BMW. Like the 750iL, it has a remote-control driving option. It is an impressive blend of beautiful design, precision engineering and gadgetry.

THE SPORTY, LUXURIOUS Z8 is one of the most advanced cars Q Branch has ever entrusted to 007's care, making its destruction by Elektra King's buzz-saw helicopters all the more shocking. Underneath the sleek body lies a powerful radar-guided weapons system – 'the very latest in intercept and counter-measures', as Q's assistant informs Bond. The Z8's impressive remote-control system allows Bond to drive using controls concealed in the ignition key, which turns out to be indispensable at ex-KGB agent Valentin Zukovsky's caviar factory.

This luxury roadster from BMW claimed a 0–60mph of just 4.7 seconds and a top speed of 155mph (249km/h). Its design was influenced by the classic BMW507 of the 1950s.

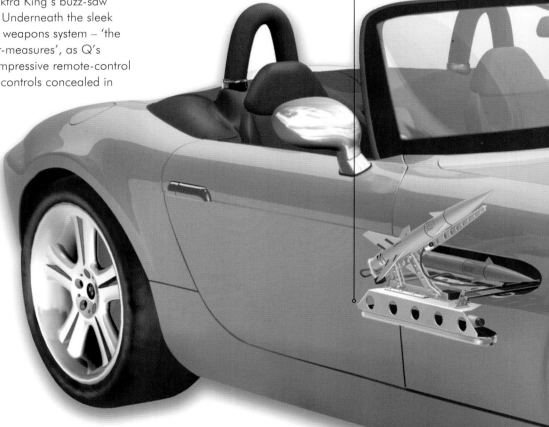

ROCKET LAUNCHER

Fully automated Stinger missiles flip out from each of the car's side air vents. Radar and laser-scanning enable rapid identification of the target and accurate firing.

Bond with the Z8 at Q Branch.

REMOTE-CONTROL SYSTEM

1. Ignition key
2. Steering pad
3. Brake pad
4. Accelerator pad
5. Alarm settings in lid

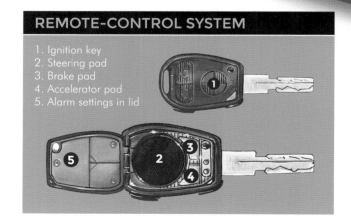

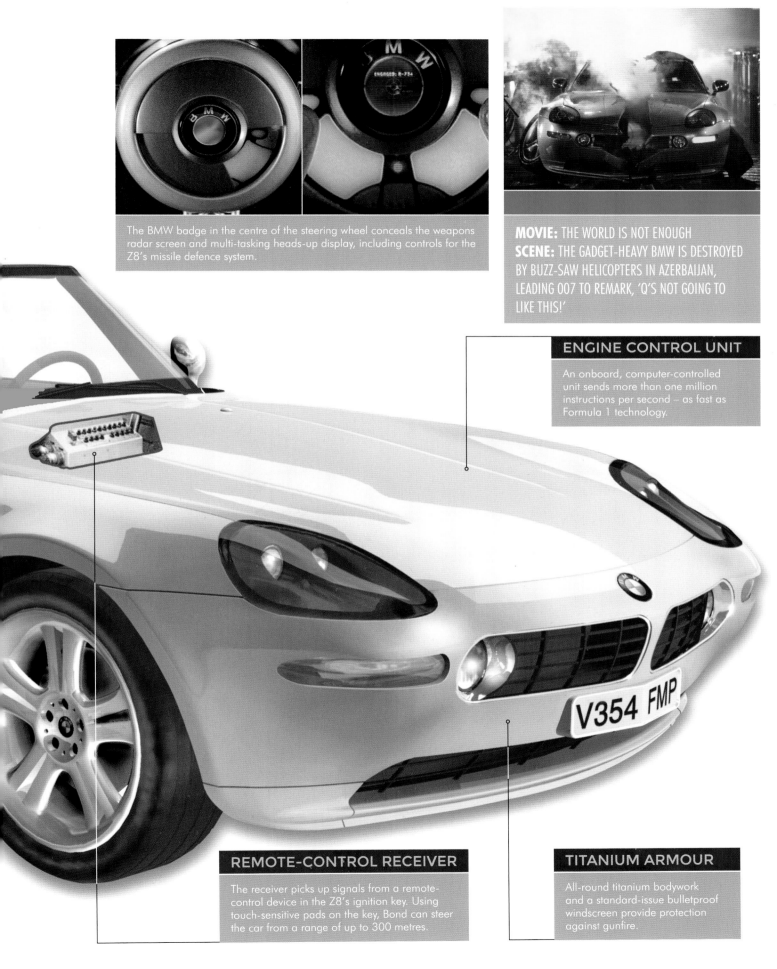

The BMW badge in the centre of the steering wheel conceals the weapons radar screen and multi-tasking heads-up display, including controls for the Z8's missile defence system.

MOVIE: THE WORLD IS NOT ENOUGH
SCENE: THE GADGET-HEAVY BMW IS DESTROYED BY BUZZ-SAW HELICOPTERS IN AZERBAIJAN, LEADING 007 TO REMARK, 'Q'S NOT GOING TO LIKE THIS!'

ENGINE CONTROL UNIT

An onboard, computer-controlled unit sends more than one million instructions per second – as fast as Formula 1 technology.

V354 FMP

REMOTE-CONTROL RECEIVER

The receiver picks up signals from a remote-control device in the Z8's ignition key. Using touch-sensitive pads on the key, Bond can steer the car from a range of up to 300 metres.

TITANIUM ARMOUR

All-round titanium bodywork and a standard-issue bulletproof windscreen provide protection against gunfire.

ASTON MARTIN

At first glance a luxurious, high-performance road car, Bond's Aston Martin in *Die Another Day* boasts a mass of high-tech gadgets and weaponry, plus a very special feature.

AT 007'S UNDERGROUND briefing in *Die Another Day*, Q describes Bond's new Vanquish as 'the ultimate in British engineering'. The V12 is certainly the most cutting-edge vehicle ever devised by Q Branch. Bond can barely believe the car's unique feature – invisibility camouflage. 007 puts every piece of its state-of-the-art offensive and defensive technology to the test when he battles Zao, who is driving a Jaguar XKR, on the ice.

The 12-gauge shotguns hidden under the bonnet use tracking radar to shoot down mobile targets such as enemy fire. The Close-in Weapons System (CIWS) is based on Phalanx and Goalkeeper defence programmes used by the US and British military.

HEAT-SEEKING TORPEDOES

Concealed behind the retractable front air-intake grille, four computer-guided missiles are equipped with armour-piercing warheads.

MACHINE GUNS

An updated version of the original front wing machine guns on Bond's Aston Martin DB5 can be deployed against short-range targets.

ADAPTIVE CAMOUFLAGE

Tiny cameras hidden on all sides of the V12 project the image they see onto a light-emitting polymer skin on the opposite side of the car. This creates an invisibility effect under most lighting conditions. As Q says to Bond, 'Aston Martin call it the Vanquish. We call it the Vanish.' The system is vulnerable to failure under heavy bombardment.

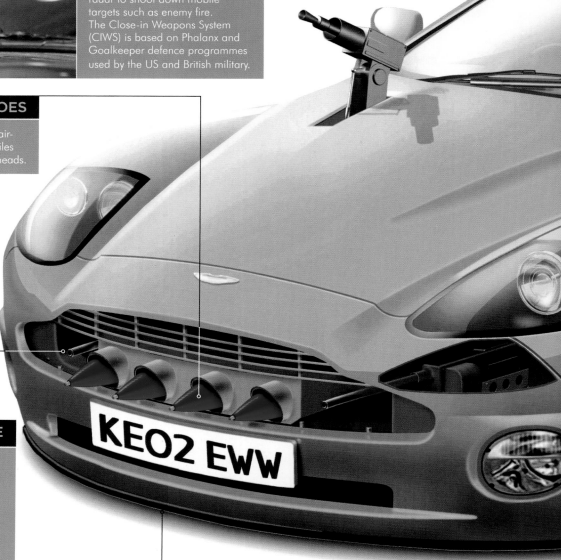

KE02 EWW

V12 VANQUISH

Bond's Vanquish and Zao's XKR are both fitted with a wide range of weapons that make them a match for one another. Bond finally tricks Zao into driving into the icy water – and his death – with his car's adaptive camouflage.

EJECTOR SEAT

007 activates the Vanquish's ejector seat to flip the car upright again after it is turned upside down by one of Zao's missiles.

MOVIE: DIE ANOTHER DAY
SCENE: AFTER BEING GIVEN THE V12 BY Q, BOND USES ALL ITS CAPABILITIES IN HIS VEHICLE BATTLE WITH ZAO'S JAGUAR

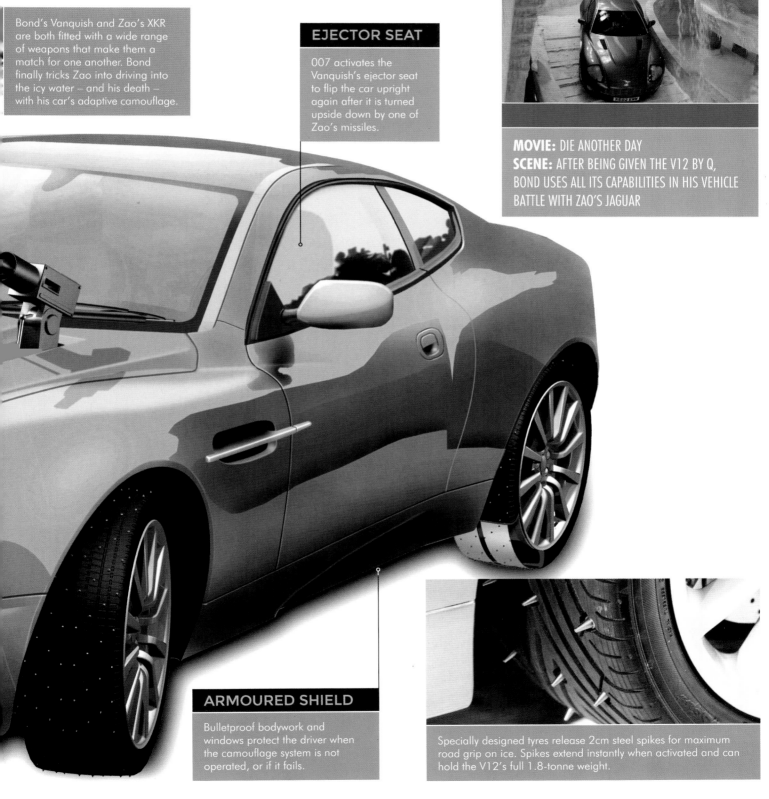

ARMOURED SHIELD

Bulletproof bodywork and windows protect the driver when the camouflage system is not operated, or if it fails.

Specially designed tyres release 2cm steel spikes for maximum road grip on ice. Spikes extend instantly when activated and can hold the V12's full 1.8-tonne weight.

ASTON MARTIN

In *Casino Royale*, MI6 gives Bond the keys to a brand new, beautiful Aston Martin DBS V12. This is a car combining road-going elegance with outstanding racing speed and handling.

WHEN VESPER LYND IS KIDNAPPED in Montenegro by Le Chiffre's men, Bond needs all the Aston Martin's power and resilience as he gives chase. Suddenly, out of the darkness, he sees Vesper bound and lying in the middle of the road. Turning at the last second, he dodges her, but the car is sent into seven full rotations. This set a World Record for the most cannon rolls in a car on film.

SWAN WING DOORS

The DBS doors open out and slightly upwards, in an elegant yet practical design. There is less chance of damaging the expensive paintwork on a high kerb, and getting in and out is easier.

RACING BODY SHAPE

The DBS echoes Aston Martin's successful DBR9 race car with a muscular design, aerodynamic front spoiler and rear diffuser.

UNIQUE STRUCTURE

Aston Martin uses a unique bonded aluminium structure for all its cars. Highly rigid, it improves handling and stability. Being exceptionally light, it also produces impressive acceleration and speed.

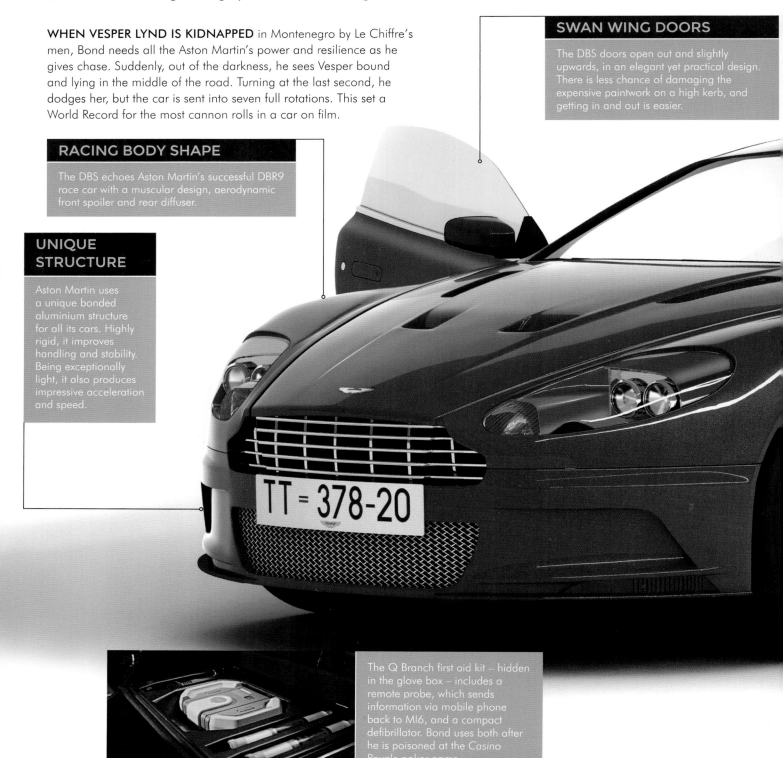

The Q Branch first aid kit – hidden in the glove box – includes a remote probe, which sends information via mobile phone back to MI6, and a compact defibrillator. Bond uses both after he is poisoned at the *Casino Royale* poker game.

DBS ▮

Concealed in a tray beneath the glove box is Bond's automatic handgun fitted with a silencer.

MOVIE: CASINO ROYALE
SCENE: BOND CHASES LE CHIFFRE AND HIS MEN AFTER THEY KIDNAP VESPER. HE AVOIDS HITTING VESPER, BUT HIS CAR TURNS OVER AND CRASHES

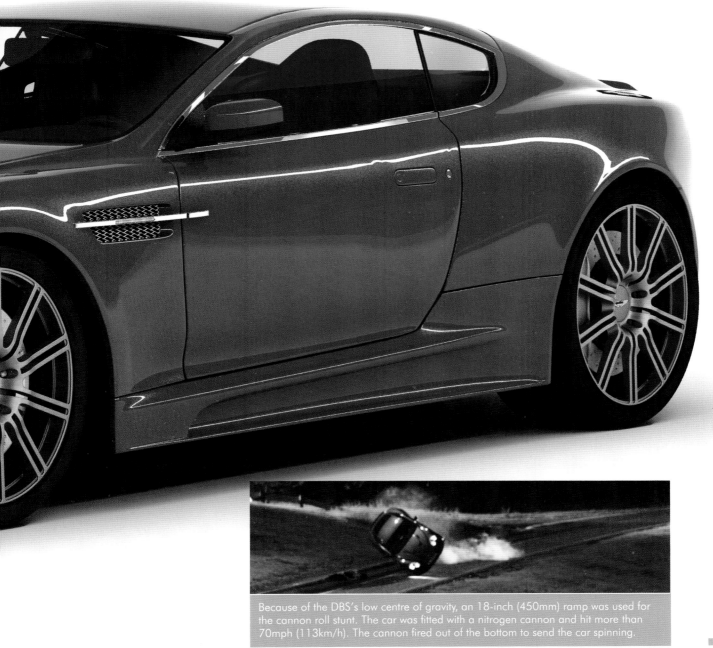

Because of the DBS's low centre of gravity, an 18-inch (450mm) ramp was used for the cannon roll stunt. The car was fitted with a nitrogen cannon and hit more than 70mph (113km/h). The cannon fired out of the bottom to send the car spinning.

ASTON MARTIN

Built at Q Branch for 007, reassigned to 009, then 'borrowed' by 007 for a clandestine trip to Rome, this spectacular supercar gives Bond the power and gadgetry to escape Mr. Hinx.

AFTER BOND IS FOUND spying on a SPECTRE meeting, he escapes in the DB10. The supercar has 'a few little tricks up her sleeve', according to Q. Bond has no idea what those tricks are, as he pushes the borrowed prototype to its limits in a bid to lose Hinx's closely matched Jaguar C-X75. The DB10's speed and handling – and Bond's driving skill – keep him just ahead of his pursuer, while the lo-tech of the prototype's four switches belies some phenomenally hi-tech gadgetry that helps 007 make a perfect getaway.

In a collaborative 'first' for the Bond series, Aston Martin created the DB10 exclusively for the movie. Ten hand-built cars were made, of which eight were used for filming.

Q's makeshift switches mounted on the dash provide Bond with valuable assistance in the chase. However, their labels – BACKFIRE, ATMOSPHERE, EXHAUST and AIR – do not make their function immediately clear.

The chase ends with Bond crashing into the Tiber and 'vanishing'. In fact he has pressed EJECT and parachuted safely to street level.

SOUND SYSTEM

ATMOSPHERE provides in-car music for agent 009.

ENGINE

The supercar's engine is a 6.0 Litre 48-valve V12 with 510 hp (380 kW) at 6500 rpm, which gives the car a top speed of 307 km/h.

BODY ARMOUR

Described by Q as 'fully bulletproof', the DB10's body armour proves its worth as Bond escapes SPECTRE's night-time meeting in Rome and drives off in a shower of bullets that do no more than bounce off the bodywork and windows.

DB10

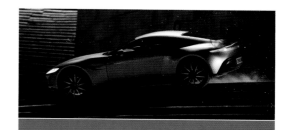

EJECTOR SEAT

The EJECT switch on the gear stick jettisons the roof and fires the driver's seat into the air.

MACHINE GUN

The BACKFIRE switch operates a sentry machine gun which extends from the ASTON MARTIN wings badge at the rear of the car.

MOVIE: SPECTRE
SCENE: BOND IS PURSUED THROUGH THE NARROW STREETS OF ROME AND ALONG THE TIBER BY MR. HINX IN HIS JAGUAR C-X75

HEADS UP DISPLAY

A digital targeting overlay on the rear window enables the machine gun to lock onto its target before firing.

AIR

Deploying the AIR switch triggers a rapid series of events: the steering wheel retracts; the driver's parachute fastens automatically; and the EJECT switch under the flip cap of the gear stick is revealed.

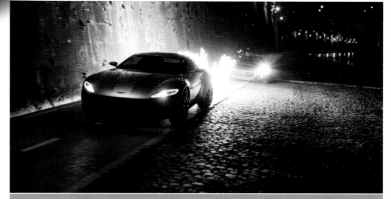

Bond takes the DB10 before it is fully equipped and is frustrated that not all of its special features have been installed. However, the EXHAUST switch does fire two very powerful jets of flame from the back of the DB10.

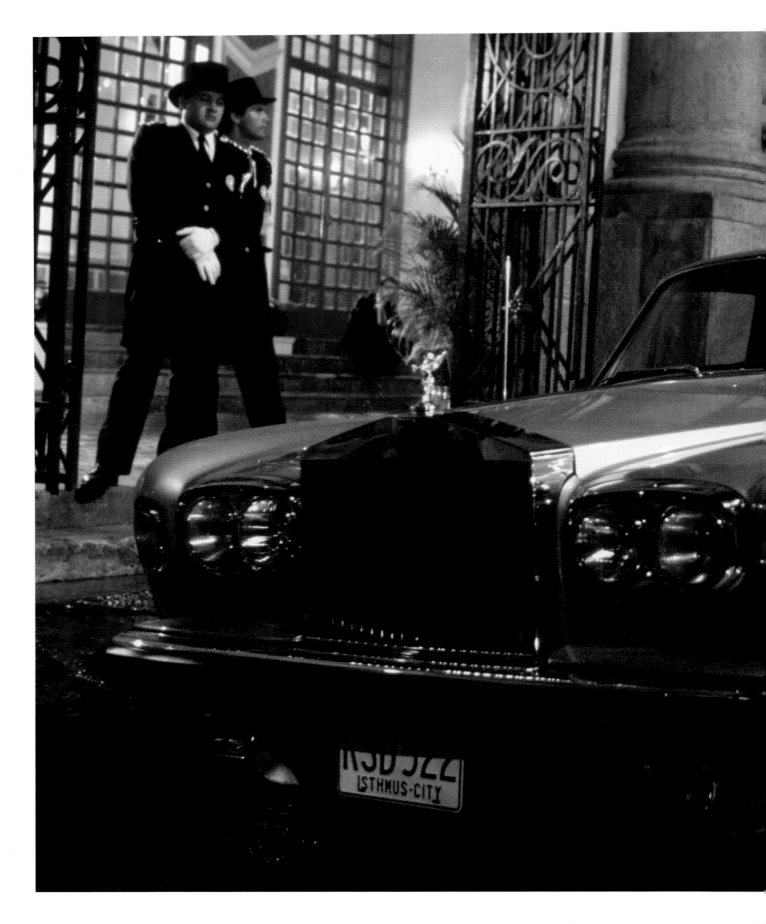

DRIVEN BY BOND'S

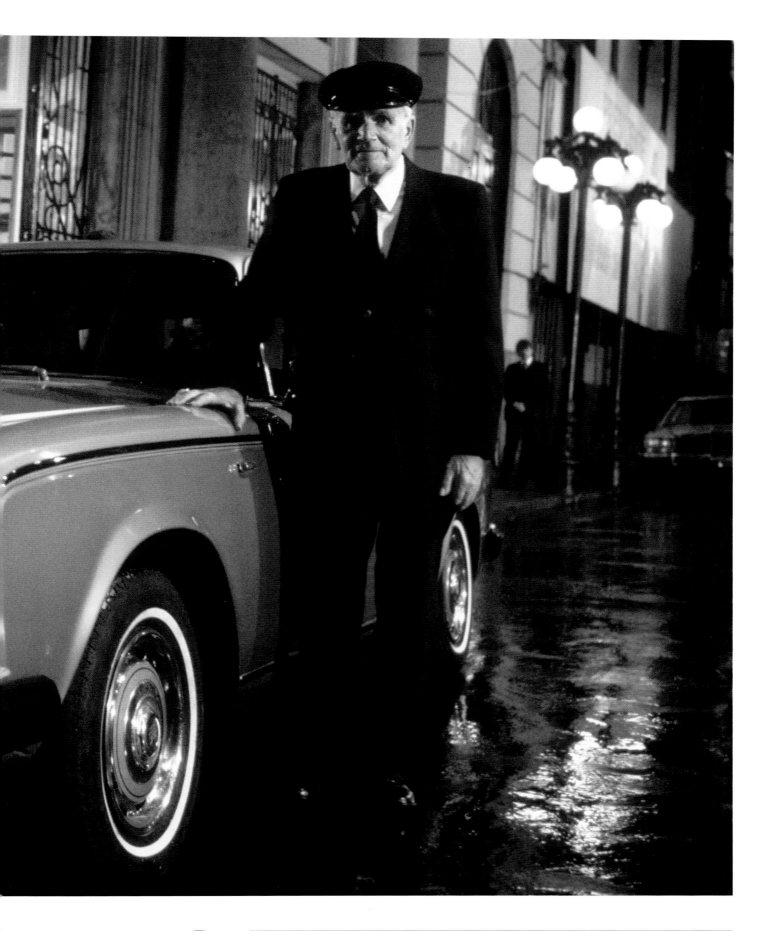

TOYOTA 2000GT

Speed, gadgetry and style – Bond enjoys a fitting getaway car while in the care of the Japanese Secret Service. Although 007 isn't behind the wheel, the Toyota 2000GT still comes to his rescue – twice.

THE 2000GT, JAPAN'S FIRST SUPERCAR, relies on its impressive speed and handling to make a quick getaway, since it has no weapons. The Toyota belongs to Japanese agent Aki, who saves Bond from gunmen at Osato Chemicals on two occasions, the second time involving a car chase.

Aki's vehicle had to be significantly modified for *You Only Live Twice*. There never was a production 2000GT convertible; Toyota had to create the illusion of a soft top to accommodate the demands of filming – and a tall leading man. Moreover, although it is seen only briefly on screen, the car was fitted with Sony's state-of-the-art communication technology.

POP-UP HEADLIGHTS

Secondary headlights pop up from the bonnet, just above the front driving lights.

VIDEO CAMERAS

Secret surveillance cameras, concealed behind the front and rear licence plates, feed images to the video recorder in the glove compartment.

Field agent Aki works for Secret Service chief Tiger Tanaka. She is assigned to help Bond with his mission.

WIRE WHEELS

Eye-catching chrome wire wheels are a nod to classic British sports cars such as the Jaguar E-type and Aston Martin DB5. These wheels only appeared on the 2000GT prototypes.

REAR COMMUNICATIONS CONSOLE

This is Japanese Secret Service technology at its best: the communication set, installed behind the seats, provides a small TV screen, two cameras and an FM transceiver. Aki can communicate with Tanaka at HQ on a secure frequency and also watch live feeds from HQ cameras.

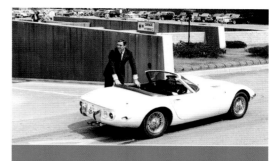

MOVIE: YOU ONLY LIVE TWICE
DRIVEN BY: AKI
SCENES: ESCAPING FROM MR. OSATO'S HITMEN

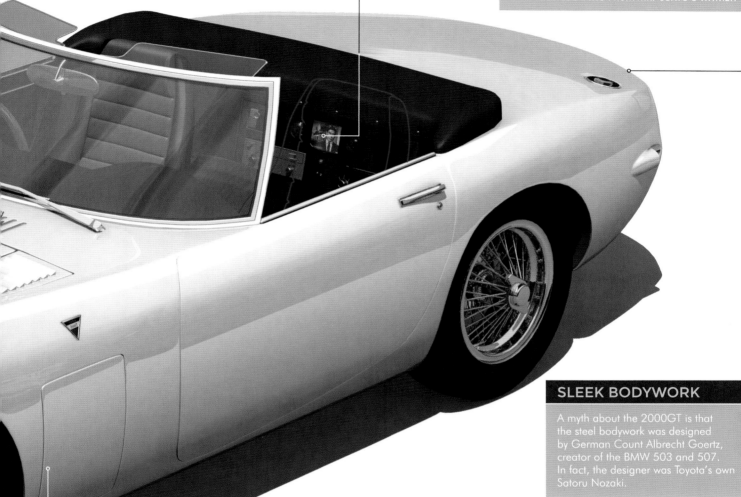

SLEEK BODYWORK

A myth about the 2000GT is that the steel bodywork was designed by German Count Albrecht Goertz, creator of the BMW 503 and 507. In fact, the designer was Toyota's own Satoru Nozaki.

Chased by SPECTRE gunmen as she helps Bond escape for a second time, Aki calls for assistance. A two-rotor Kawasaki KV-107 helicopter descends and uses a large magnet to pick up the pursuing vehicle and carry it away before dropping it in the sea.

WING SERVICE HATCHES

Standard-issue, fibreglass service hatches do not conceal lethal weapons but provide easy access to the 2000GT battery, air filter and windscreen-washer bottle.

FORD THUNDER

Loaded with 1950s motoring heritage, Jinx's Ford Thunderbird is nevertheless modern, sporty and stunning – ideal for an NSA operative on a mission.

NSA AGENT JINX is assigned to kill rogue North Korean agent Zao, who is undergoing gene replacement therapy at the Alvarez clinic on Los Organos island, Cuba. There she meets James Bond, also on the trail of Zao. The rogue agent evades them, but Jinx tracks him to billionaire Gustav Graves' diamond mine in Iceland.

Arriving in her coral Ford Thunderbird at Graves' public demonstration of the Icarus Satellite at his Ice Palace, Jinx once again crosses paths with Bond. They team up to take down Graves, Zao and double agent Miranda Frost.

Jinx's 2003 Thunderbird is an American classic, updating countless styling cues from the 1955 original.

JINX COLOUR

The coral paint is similar to the Sunset Coral hue offered on the 1956 Thunderbird.

ANGLED SCREEN

The trademark wrap-around windscreen is set at a 64-degree angle and trimmed in chrome.

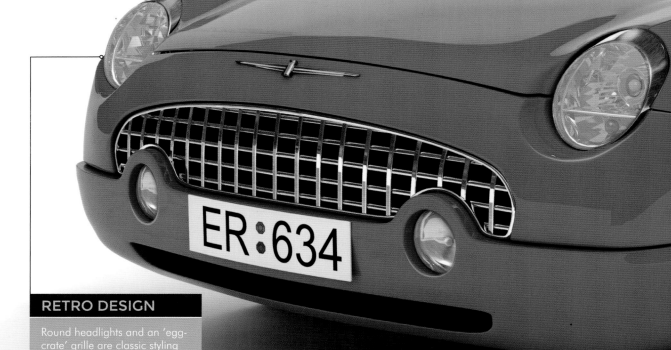

ER:634

RETRO DESIGN

Round headlights and an 'egg-crate' grille are classic styling features from the 1955 T-Bird. The round inset lights are not fog lights but parking lights as on the original.

Jinx arrives at Gustav Graves' Ice Palace in Iceland and is greeted by a valet. The diamond magnate is about to unveil a laser that will provide year-round sunshine wherever it is focused.

BIRD

DESIGN TRIM

Chrome slash marks on the front quarter panels reinterpret the 1957 model's prominent slash marks.

LINCOLN BASE

To reduce costs, the 2003 Thunderbird shares its chassis, engine and gearbox with a Lincoln LS.

MOVIE: DIE ANOTHER DAY
DRIVEN BY: JINX
SCENE: DRIVEN TO GUSTAV GRAVES' ICE PALACE IN ICELAND

RAISE THE ROOF

The removable hardtop features porthole windows similar to the 1956 model. The standard electric convertible fabric top can be raised in 20 seconds.

DESIGNER RIMS

The standard model has either 7-blade chrome wheels or painted cast aluminium wheels. The limited-edition 007 model featured chrome 21-spoke wheels.

At the Ice Palace party, Jinx reunites with James Bond at the ice bar.

ZAZ-965A

CIA agent Jack Wade's diminutive ZAZ-965A makes unlikely transport for 007 across St Petersburg. He travels in it to meet Mafia boss Valentin Zukovsky at his nightclub.

WHEN BOND ARRIVES in St Petersburg, Russia, he finds that his eccentric CIA contact, Jack Wade, drives a small blue ZAZ-965A. It's a type of car not normally associated with the British agent, but as Wade explains, his ZAZ has never let him down. At this point, the car has a major engine failure.

Soviet-era ZAZs were designed to be easily serviced by owners, since there were few garages for private cars. So sure enough, Wade manages to fix his economy drive with just a screwdriver, spanner — and a sledgehammer.

ROOF RACK

With so little room inside the ZAZ-965A, many owners fix a rack to the roof to increase luggage capacity.

UNDERPOWERED ENGINE

The ZAZ-965A's air-cooled, 887cc engine, located at the rear, produces a paltry 26bhp. The earlier ZAZ-965 has an even smaller 746cc engine that manages just 23bhp.

FUNCTIONAL VENTS

Air intakes above the rear wheels on either side of the car help cool the engine.

'SUICIDE' DOORS

Hinged on the rear edge, the doors open at the front. If a driver tries to open and re-close the door while the car is moving, rushing air will pull it out and off the car, often taking the driver with it.

When Wade meets Bond at St Petersburg airport, the CIA agent is leaning against a large, shiny Mercedes. Seeing the agent's actual vehicle is both diminutive and rather battered, Bond can't resist remarking, 'Nice car.'

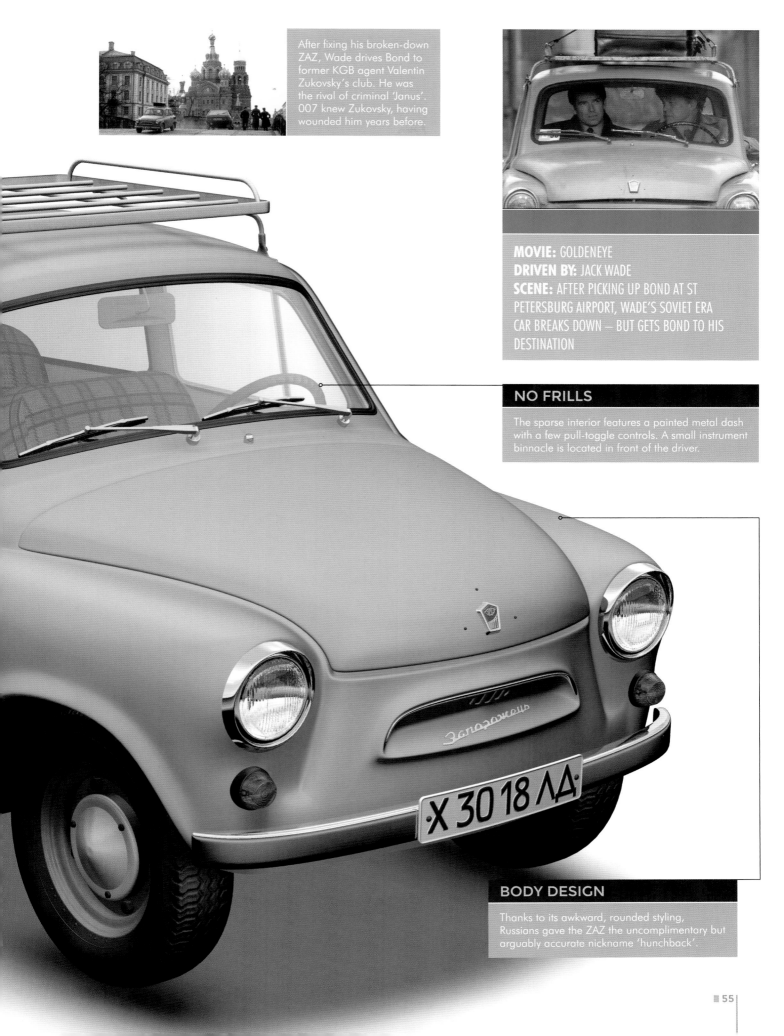

After fixing his broken-down ZAZ, Wade drives Bond to former KGB agent Valentin Zukovsky's club. He was the rival of criminal 'Janus'. 007 knew Zukovsky, having wounded him years before.

MOVIE: GOLDENEYE
DRIVEN BY: JACK WADE
SCENE: AFTER PICKING UP BOND AT ST PETERSBURG AIRPORT, WADE'S SOVIET ERA CAR BREAKS DOWN — BUT GETS BOND TO HIS DESTINATION

NO FRILLS

The sparse interior features a painted metal dash with a few pull-toggle controls. A small instrument binnacle is located in front of the driver.

BODY DESIGN

Thanks to its awkward, rounded styling, Russians gave the ZAZ the uncomplimentary but arguably accurate nickname 'hunchback'.

LEYLAND SHER

The indestructible Jaws meets his match in the form of a Leyland Sherpa van that refuses to give, despite being ripped apart by the muscular henchman.

JAWS USES a Telephone Service Sherpa van as part of his disguise to get into Max Kalba's club, where he recovers the microfilm containing details of Stromberg's submarine tracking device. After Bond spots Jaws, he and Russian agent Anya Amasova sneak into the back of the van, not realizing that Stromberg's henchman can hear them via a hidden microphone.

Driving to nearby ruins, Jaws attempts to eliminate his stowaways, but the two secret agents recover the microfilm and rush back to the van. Their escape is hampered by Jaws, who begins tearing the van apart with his hands. Amasova drives off into the Egyptian desert where the damaged van keeps going – until a blown cylinder head gasket brings them to a halt.

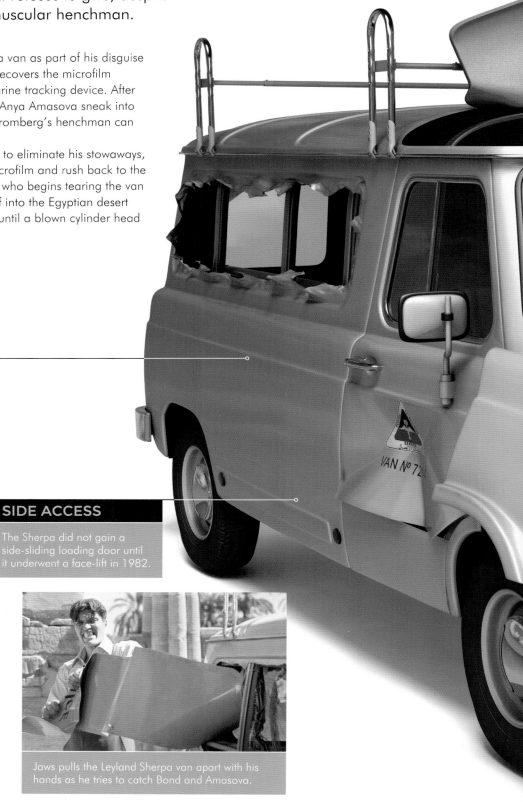

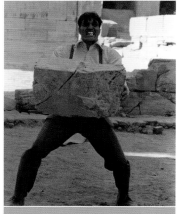

Henchman Jaws is determined to kill Bond and Amasova, but the pair escape in the van.

SIDE ACCESS

The Sherpa did not gain a side-sliding loading door until it underwent a face-lift in 1982.

LOAD CAPACITY

Thanks to its flat sides, the Sherpa's total load capacity was a competitive 190cu ft.

Jaws pulls the Leyland Sherpa van apart with his hands as he tries to catch Bond and Amasova.

PA VAN

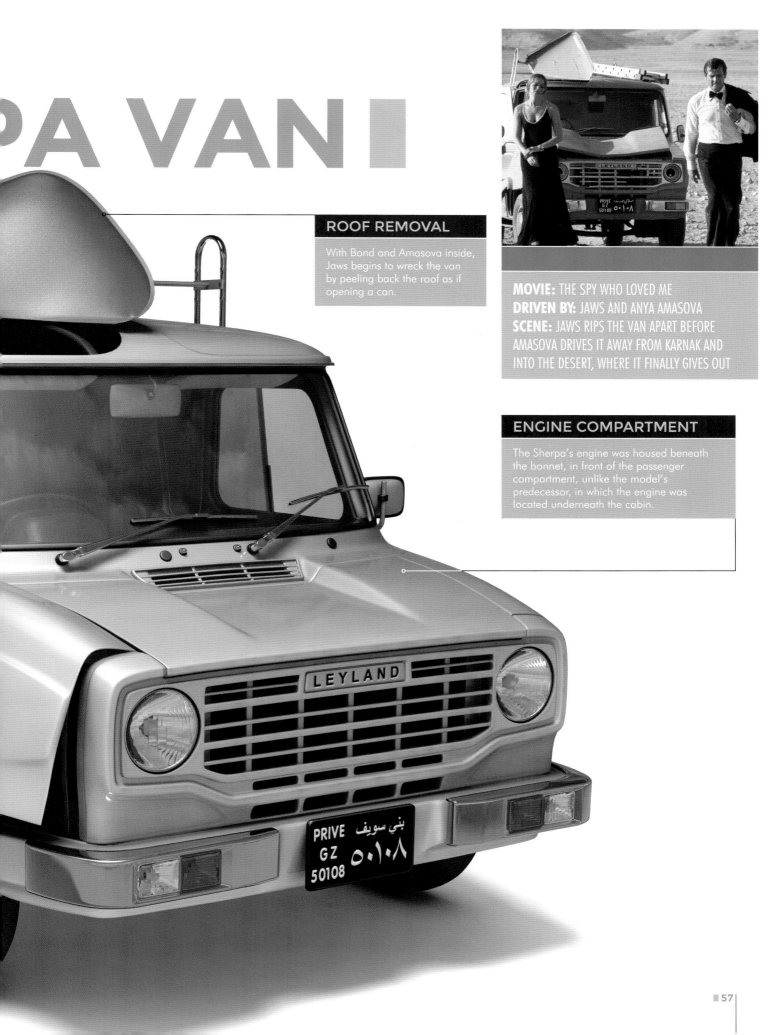

ROOF REMOVAL

With Bond and Amasova inside, Jaws begins to wreck the van by peeling back the roof as if opening a can.

MOVIE: THE SPY WHO LOVED ME
DRIVEN BY: JAWS AND ANYA AMASOVA
SCENE: JAWS RIPS THE VAN APART BEFORE AMASOVA DRIVES IT AWAY FROM KARNAK AND INTO THE DESERT, WHERE IT FINALLY GIVES OUT

ENGINE COMPARTMENT

The Sherpa's engine was housed beneath the bonnet, in front of the passenger compartment, unlike the model's predecessor, in which the engine was located underneath the cabin.

LEYLAND

PRIVE بني سويف
GZ ٥٠١٠٨
50108

MP LAFER

A symbol of elegance and good taste, the open-topped MP Lafer provided the perfect means of transport for MI6's field agent Manuela in sunny Rio de Janeiro.

JAMES BOND'S MISSION to track down the missing Moonraker shuttle takes him to Brazil, where he finds himself being tailed by a woman driving a stunning car: an MP Lafer. This open-top sports car darts in and out of the traffic with the woman taking surveillance photographs of 007's Rolls-Royce. As Bond nears his destination, the MP Lafer roars away. Only later does 007 discover that the woman is Manuela, a field agent assigned to work with him.

Built in Brazil between 1974 and 1990, the MP Lafer took its style inspiration from classic British sports cars, making it the perfect car for Bond to encounter on a mission in South America.

TRADEMARK

The MP badge is a copy of the traditional MG badge and is found on the grille, the steering wheel and the spare wheel at the back.

BEETLE POWER

The VW 1.6-litre engine may not have provided scintillating performance, but it was certainly reliable and easy to service.

EXTRA LIGHTS

The MP Lafer is a highly faithful replica of the 1952 MG-TD, with the exception of the extra spotlights mounted in front of the grille.

DOOR DIFFERENCE

The MG-TD had rear-hinged 'suicide' doors (inclined to suck out occupants) but the Lafer featured the more conventional front-hinged type.

Manuela tells Bond the name of the airport that Drax Air Freight uses and he heads off to observe it from the cable car station at the top of Sugarloaf Mountain.

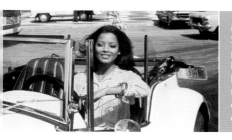

Manuela, a Secret Service operative in Rio, photographs 007 from her MP Lafer en route to his hotel. When Bond gets to his room, Manuela is already there to tell him about Drax Industries.

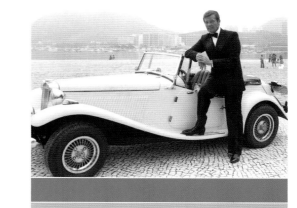

MOVIE: MOONRAKER
DRIVEN BY: MANUELA
SCENE: THE FIELD AGENT WEAVES THROUGH RIO'S TRAFFIC WHILE TAKING PHOTOS OF BOND IN THE BACK OF A ROLLS-ROYCE

SIGNATURE STYLE

As the engine is air-cooled and located at the rear, the radiator grille was non-functional, although the radiator cap served as the mouth of the petrol tank.

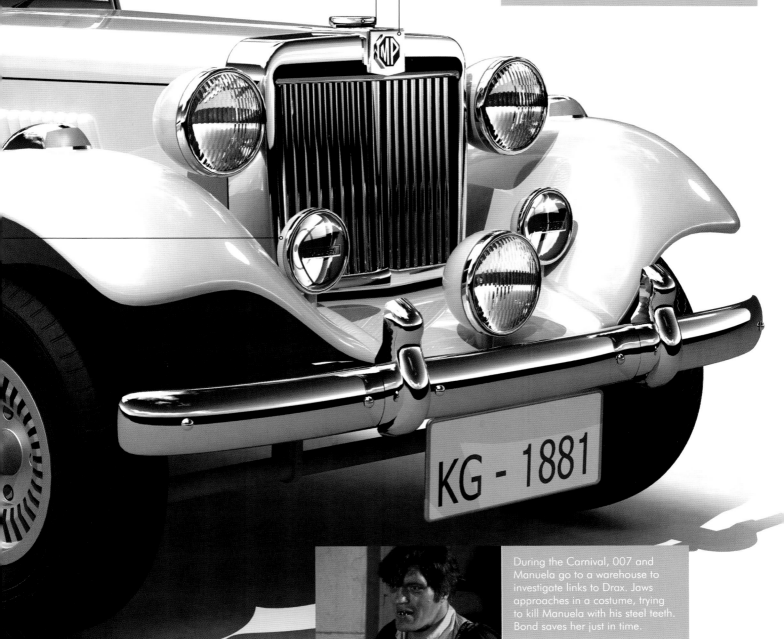

KG - 1881

During the Carnival, 007 and Manuela go to a warehouse to investigate links to Drax. Jaws approaches in a costume, trying to kill Manuela with his steel teeth. Bond saves her just in time.

FORD MUSTANG

Ford's stunning new sports car, the Mustang, made its big screen debut in 1964's *Goldfinger*, wowing audiences even while being sliced open by the Aston Martin DB5's tyre slasher.

INTENT ON TAKING her revenge on Goldfinger for the death of her sister Jill, Tilly Masterson tracks him down to Switzerland where she follows him in her cream-coloured Ford Mustang. After Tilly attempts but fails to shoot Goldfinger, Bond pursues her in his Aston Martin DB5. He uses the DB5's tyre slasher to destroy two of the Mustang's tyres, forcing the car off the road.

Ford began production of the Mustang in March 1964, with its official unveiling taking place on 17 April 1964 at the World's Fair. *Goldfinger* was released in September of that year, giving many outside North America their first good look at Ford's iconic car. The following year, in *Thunderball*, SPECTRE assassin Fiona Volpe drives a blue Ford Mustang convertible with the white roof up, picking up Bond and taking him on a fast ride back to his hotel in Nassau.

AUTOMATIC OPTION

The standard roof is raised and lowered by hand. An optional power roof cost $52.95 in 1965. Tilly has the standard option.

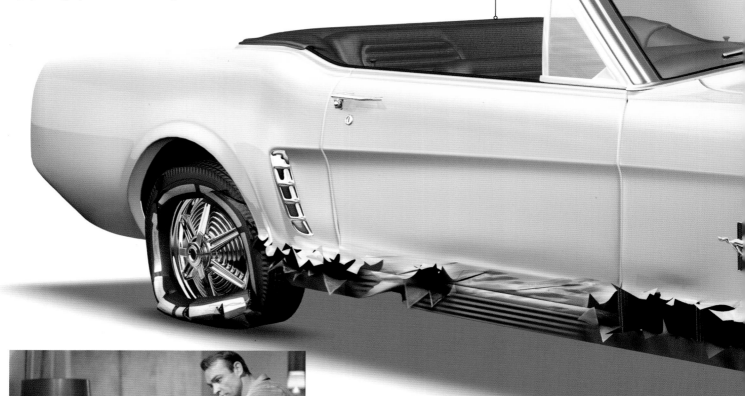

Goldfinger has Jill Masterson killed for her betrayal with Bond. Assassin Oddjob knocked Jill unconscious and painted her entire body in gold paint, causing her death.

The tyre shredder on Bond's DB5 destroys the tyres and bodywork on the Mustang's passenger side. Close-ups of the damage were filmed at Pinewood using a fake Mustang panel made of fibreglass.

Tilly pursues Goldfinger's Rolls-Royce on the narrow mountain roads. She plans to shoot him in revenge for murdering her sister Jill.

MOVIE: GOLDFINGER
DRIVEN BY: TILLY MASTERSON
SCENE: TILLY HUNTS GOLDFINGER THROUGH THE SUNNY SWISS ALPS AND ENCOUNTERS BOND

FALCON CHASSIS

The chassis, suspension and engine are all based on the existing Ford Falcon and the Ford Fairlane to minimize costs.

GEARBOX CHOICE

Owners could order the Mustang with a three-speed manual transmission, a Borg-Warner T-10 four-speed manual, or Ford's three-speed Cruise-O-Matic automatic.

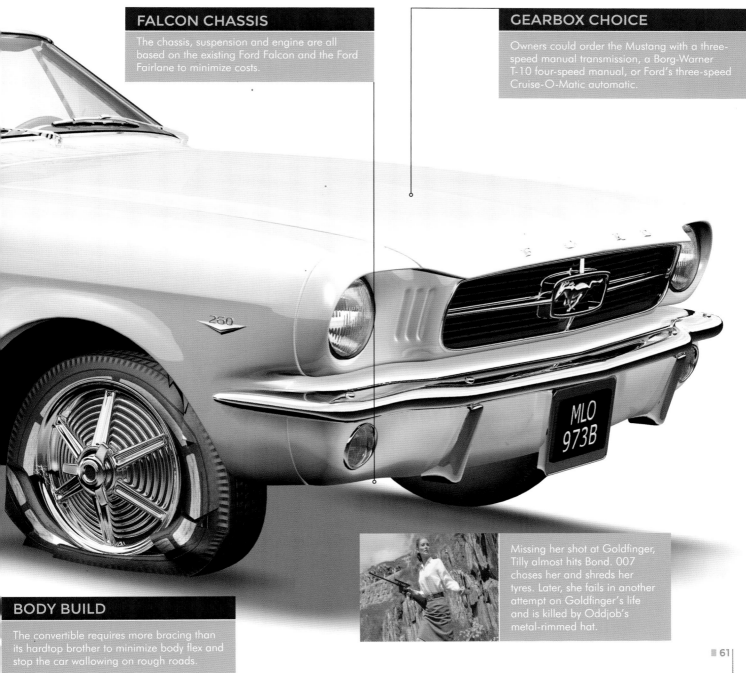

BODY BUILD

The convertible requires more bracing than its hardtop brother to minimize body flex and stop the car wallowing on rough roads.

Missing her shot at Goldfinger, Tilly almost hits Bond. 007 chases her and shreds her tyres. Later, she fails in another attempt on Goldfinger's life and is killed by Oddjob's metal-rimmed hat.

MERCURY COUG

When he needs to make a quick getaway from Blofeld's heavies, Bond is lucky to find his fiancée, Tracy, and her powerful American sports car – a convertible Mercury Cougar.

RACING DOWN THE DUSTY coastal roads of Portugal and chasing along the icy passes of Switzerland, the Mercury Cougar effortlessly looks the part, and with a Ford big block engine under the bonnet, this pony car certainly has the horsepower to escape its SPECTRE pursuers. Taking Tracy and Bond through a small village and even getting caught up in an ice-track car race, they eventually take shelter from a blizzard by hiding in a barn, where Bond confesses his love for her and proposes.

Tracy drives the convertible version – brand new in 1969 – with the soft top roof down when she first overtakes Bond on the road to the beach. Later she drives with the roof raised as she and 007 escape Blofeld's men in Switzerland.

A specially designed ski rack, mounted on the boot, carries winter sports equipment.

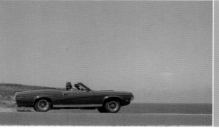

Bond first sees Tracy di Vicenzo (played by Diana Rigg) in his rear-view mirror as her car pulls up behind his DBS, then overtakes him on the twisting road. Rigg's impressive driving skills meant that it is she rather than a stunt person often seen at the wheel of the Cougar.

SUSPENSION

Based on the Ford Mustang platform, better-rated rear spring and axle attachments increase the ride comfort.

AR

RAM AIR INDUCTION SCOOP

A new option for 1969, the ram air induction bonnet scoop directs cooler, denser air to the engine compartment, increasing engine power.

The Cougar is driven by Tracy di Vicenzo, the troubled daughter of Corsican crime baron Marc-Ange Draco.

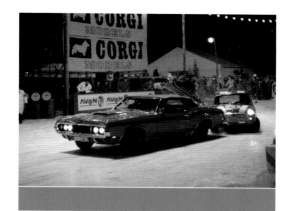

MOVIE: ON HER MAJESTY'S SECRET SERVICE
DRIVEN BY: TRACY
SCENE: ON THE COAST ROAD IN PORTUGAL AND IN THE SWISS ALPS, WHERE TRACY HELPS BOND ESCAPE HIS SPECTRE PURSUERS, RESULTING IN A FRANTIC CAR CHASE

COBRA JET ENGINE

Tracy's Mercury Cougar boasts Ford's big block 428 Cobra Jet engine, underrated at 335bhp and 5,200rpm. Built for speed rather than smoothness over distance, it proved popular with street racers in the US.

HIDDEN HEADLIGHTS

When not in use, the headlights tuck away neatly behind the horizontal bars of the front grille – one of the classic design cues of the Mercury Cougar.

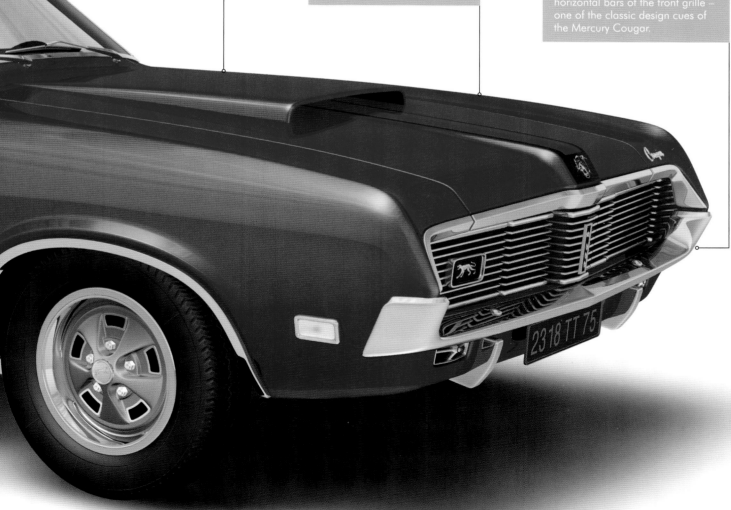

LAND ROVER L

The Land Rover Lightweight was specifically designed so that it could be dropped by parachute, and it provides the perfect means of escape for Bond and Kara Milovy when their plane springs a fuel leak.

KARA MILOVY JUMPS into a modified Land Rover Lightweight after she is thrown from her horse during the mujahideen's attack on the Soviet base in Afghanistan. A Russian soldier jumps on the bonnet, but she manages to dislodge him. As 007 taxis along the runway in a Hercules C-130, Kara drives the Lightweight into the hold via the cargo ramp, before securing it on a special airdrop pallet. Later, with the plane fast losing fuel, Bond and Kara strap themselves into the Land Rover and release the pallet's parachute, which pulls them out the back of the plane and allows them to float safely to the ground as the plane crashes, destroying the drugs on board.

The Land Rover Lightweight, in production from 1968 to 1984, was made for the military. As its name implies, it was lighter than regular Land Rovers so it could be dropped by parachute, which 007 puts to good use.

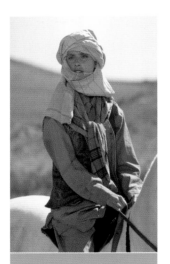

Kara convinces Kamran Shah to attack the Soviet airbase and help Bond.

38-60 ВШ

DELIVERY DEVICE

When transported by plane, the Lightweight is secured to an airdrop pallet, also known as a stress platform. This is a light but strong metal tray that has an extractor parachute attached to pull it from the aircraft.

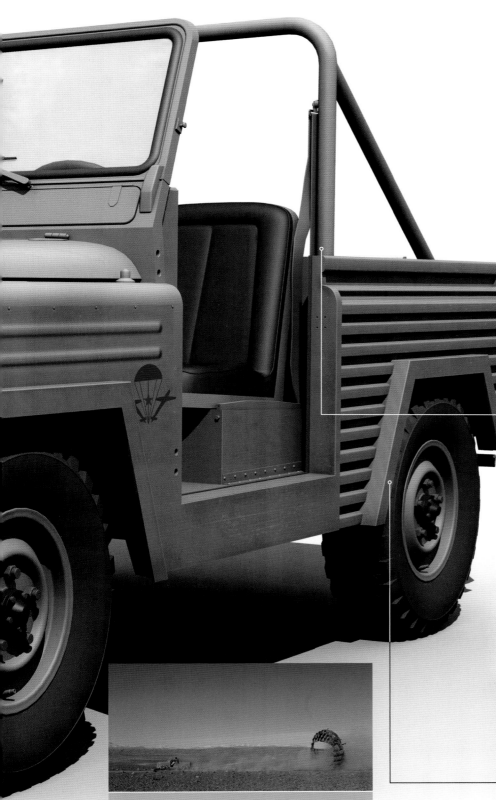

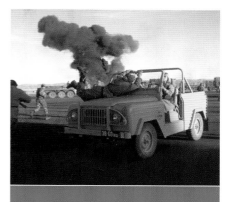

MOVIE: THE LIVING DAYLIGHTS
DRIVEN BY: KARA MILOVY
SCENE: MILOVY BOARDS THE HIJACKED CARGO PLANE IN THE LAND ROVER, AND LATER ESCAPES IN IT WITH BOND

WEIGHT SAVING

To make the vehicle as light as possible, only items deemed absolutely necessary were included. Most Lightweights were soft-tops, and fittings such as doors, some body panels, the spare wheel and rear seats were removed.

IDENTIFYING FEATURES

The angular wheel arches are a distinctive feature of the Lightweight. The corrugated rear panels are a modification made for its appearance in *The Living Daylights* and not a typical feature.

Landing safely, 007 and Kara drive towards Karachi as Bond says, 'We can just make dinner'.

RANGE ROVER CO

A stunning convertible Range Rover driven by field agent Bianca comes to James Bond's aid after he is captured during an undercover mission in South America.

A RANGE ROVER CONVERTIBLE towing a horsebox arrives at a horse-racing event at a South American military airbase. At the wheel is Bond, who is on a mission to destroy a top secret aircraft. Disguised as Colonel Toro, 007 infiltrates the airbase, but before he can plant some explosives, the real Colonel Toro turns up and his cover is blown. As Bond is driven off under armed guard, Secret Service operative Bianca swings into action. Drawing alongside the military truck in the open topped Range Rover, she distracts the guards just long enough for Bond to pull the rip cords on the parachutes they are wearing, which sends them flying out the back. Bond climbs into the Range Rover where he thanks Bianca before moving to the horse trailer that contains the Acrostar jet hidden behind a false horse.

The Range Rover on which this convertible was based was in production for 25 years, from 1970 to 1994. The combination of off-road ability with a luxurious interior proved to be hugely successful for the company and a perfect mix for a vehicle in a Bond film.

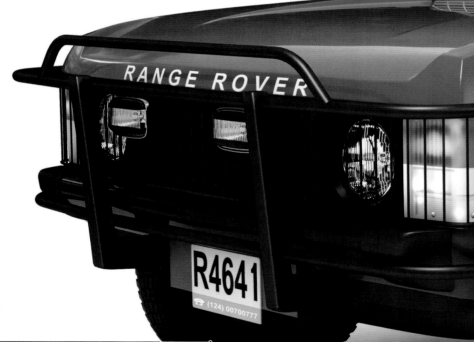

Bianca completes Bond's Colonel Toro disguise with a fake moustache.

WINNING COMBINATION

The Range Rover was designed from the beginning to be a serious off-roader, but it was also very car-like on normal roads, unlike other 4x4s of the era. It had great on-road manners and comfort thanks to its silky 3.5-litre V8 engine, long travel coil springs and disc brakes all round.

NVERTIBLE

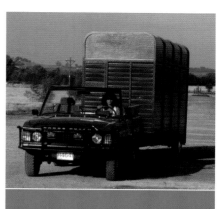

CONVERTED CONVERTIBLE

Land Rover never built an official convertible version of the Range Rover, but various specialist companies, such as the Swiss brand Monteverdi and Wood & Pickett in the UK, made limited edition cabriolet conversions from standard Range Rovers.

MOVIE: OCTOPUSSY
DRIVEN BY: BIANCA
SCENE: BIANCA DISTRACTS MILITARY GUARDS WHO HAVE CAPTURED BOND

BORN TO TOW

Thanks to its torquey V8 engine, the Range Rover had a towing capacity of 3.5 tons, making it ideal for pulling horseboxes – or indeed a trailer containing a small jet plane!

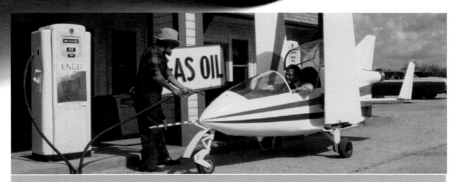

Bond pilots the Acrostar jet from the horsebox and destroys a military spy plane and the real Colonel Toro, using one of the enemies' own heat-seeking missiles. 007 then lands and pulls into a petrol station, requesting the attendant to 'fill her up, please'.

ROLLS-ROYCE S

Working with MI6, racehorse expert Sir Godfrey Tibbett drives a Rolls-Royce Silver Cloud II when he goes undercover as Bond's chauffeur, but he and the car meet a premature end.

THE OLD-SCHOOL ELEGANCE of an immaculate Rolls-Royce Silver Cloud II helps to sell Bond's cover as the wealthy horse dealer, James St. John Smythe, while investigating microchip tycoon Max Zorin. Rolling up in style at Zorin's château, no one questions St. John Smythe's credentials, giving him and his 'chauffeur' Tibbett the chance to do some snooping. Unbeknownst to them, their real identities are soon uncovered and when Tibbett takes the Rolls into town he is surprised by May Day, who strangles him from the back seat and drives the Rolls back to the château. Bond is captured by Zorin, knocked unconscious and bundled into the back of the Silver Cloud with Tibbett's body. Zorin and May Day attempt to drown Bond by pushing the Rolls into a lake.

Albert R. Broccoli, long-time Bond producer, was the owner of one of the Rolls-Royce Silver Cloud II models used in *A View To A Kill,* with the licence plate changed from CUB 1 to 354 HYK.

UNDER THE SKIN IMPROVEMENT

The coachwork of this model was virtually identical to the previous Silver Cloud. Differences included improved headlights, power-assisted steering and adjustable air vents in the dashboard. The Silver Cloud II also introduced optional extras such as electric windows and air conditioning.

May Day kills undercover agent Sir Godfrey as he takes the Rolls-Royce through a car wash. She and her employer Max Zorin plan to dispose of Bond next.

TRADITIONAL VALUES

The Rolls-Royce craftsmanship and quality of construction were impeccably high, but the styling and engineering remained traditional. Even when the Silver Cloud first appeared in 1955, it looked as if it had come from a bygone era. The separate chassis and body also meant there was surprisingly little legroom in the rear.

LVER CLOUD II

Bond, Q and Tibbett, undercover at the races, watch May Day try and control Zorin's horse, on a suspiciouly strong winning streak.

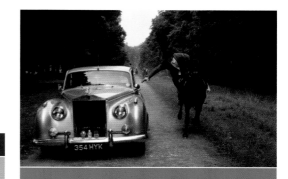

INTERIOR

The interior provided an ambience similar to an exclusive country club with the highest-quality leather, walnut wood and thick Wilton carpeting. Picnic tables in the rear were ideal for glasses of the finest Scotch.

MOVIE: A VIEW TO A KILL
DRIVEN BY: SIR GODFREY TIBBETT AND MAY DAY
SCENE: TIBBETT DRIVES BOND TO ZORIN'S CHÂTEAU IN FRANCE, BUT HE IS KILLED BY MAY DAY. SHE TAKES THE ROLLS AND SURPRISES BOND, WHO EXPECTS TO SEE TIBBETT AT THE WHEEL

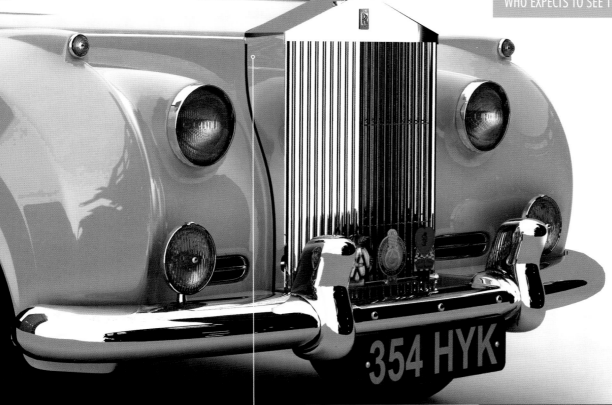

354 HYK

Dumped in a lake inside the Rolls, Bond sees Zorin and May Day waiting to shoot him, so he stays below the surface breathing air from a tyre valve.

EFFORTLESS POWER

The Silver Cloud II was the first production Rolls-Royce to use a V8 engine. This all-new aluminium 6230cc engine provided relaxed driving over long distances, as it eased to 100mph in 38.5 seconds.

MGB

Mary Goodnight, MI6's agent and Bond's contact in Hong Kong, owns a mustard-coloured MGB roadster with the early, signature feature of chrome bumpers.

TAILING ANDREA ANDERS, Scaramanga's mistress, Bond has arrived at the Hong Kong Macau Hydrofoil terminus and is about to jump in a taxi when Goodnight drives up in her MGB. With Bond as passenger, she continues to follow Anders, now travelling in a green Rolls-Royce. This leads them to the Peninsula Hotel which runs a fleet of such Rolls, and here Bond temporarily leaves Goodnight to continue his investigation of Anders.

CLASSIC CAR

The classically styled convertible made its debut in 1962, the same year that Bond hit cinema screens with *Dr. No.* MGB bowed out, after 18 years of production, in 1980, but it remains the best-selling British sports car of all time.

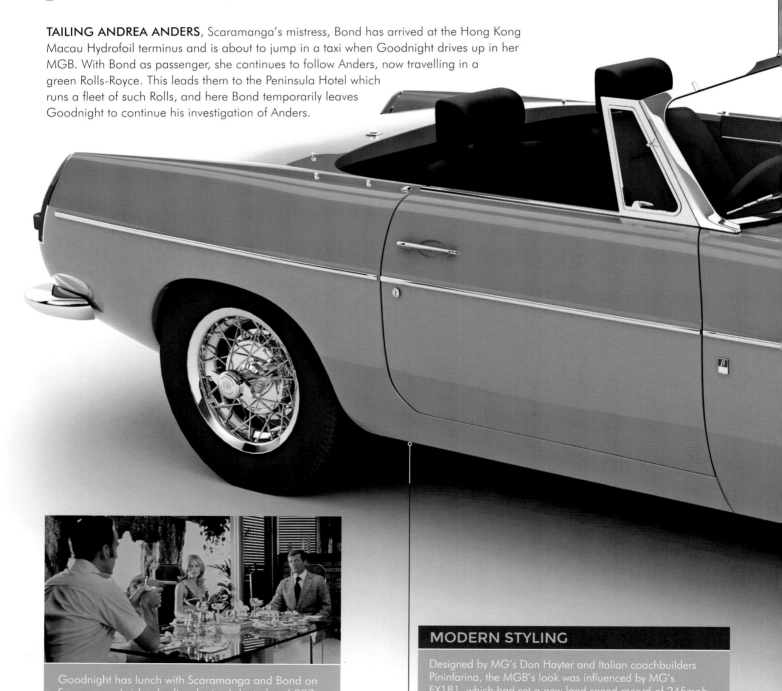

Goodnight has lunch with Scaramanga and Bond on Scaramanga's island, after she is abducted and 007 follows. Scaramanga aims his golden gun at Bond, proposing a duel with pistols.

MODERN STYLING

Designed by MG's Don Hayter and Italian coachbuilders Pininfarina, the MGB's look was influenced by MG's EX181, which had set a new land speed record of 245mph (394km/h) in 1957.

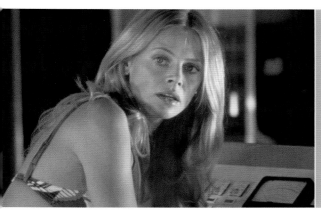

After Bond kills Scaramanga in the duel, Goodnight knocks her guard into the pool of liquid helium used to cool the solar plant. Goodnight pushes the console buttons as 007 retrieves the Solex agitator, and the pair escape just as the solar plant explodes.

MOVIE: THE MAN WITH THE GOLDEN GUN
DRIVEN BY: MARY GOODNIGHT
SCENE: DRIVING THE STREETS OF HONG KONG TO TAKE BOND FROM THE HARBOUR TO THE PENINSULA HOTEL

1.8 LITRE ENGINE

With the engine size increased from 1622cc to 1798cc, the MGB was faster than the MGA – able to cruise effortlessly at 100mph (160km/h) – despite being heavier.

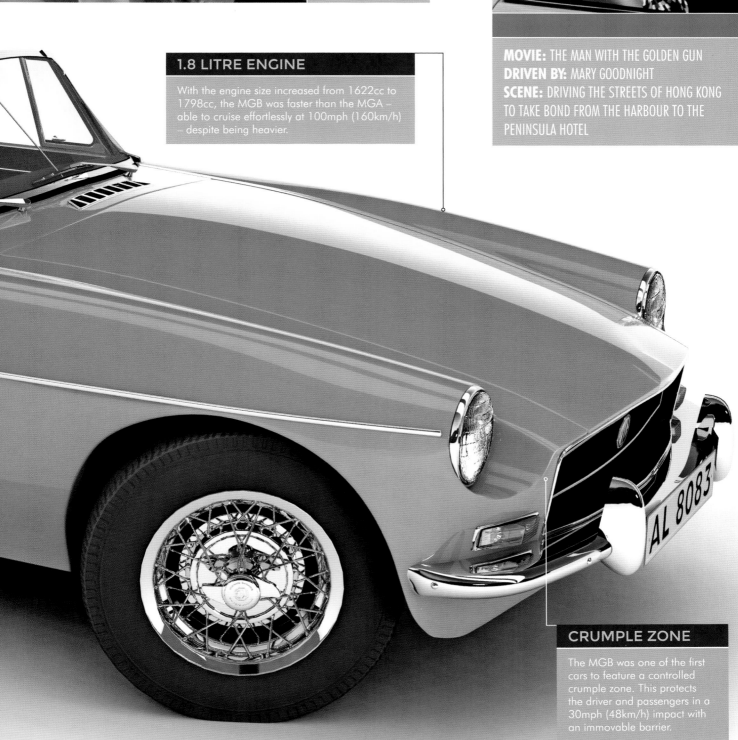

CRUMPLE ZONE

The MGB was one of the first cars to feature a controlled crumple zone. This protects the driver and passengers in a 30mph (48km/h) impact with an immovable barrier.

AL 8083

TUK-TUK

Bond and agent Vijay are pursued through narrow streets in Indian tuk-tuks with a difference – the engines have been customized to reach speeds of 70mph.

AFTER WINNING 200,000 RUPEES from Kamal Khan at backgammon, Bond leaves in a tuk-tuk driven by fellow MI6 agent Vijay. Khan's hitmen, led by Gobinda, follow them in a hair-raising chase in which Vijay drives down steps, performs wheelies and flies over a camel.

Auto rickshaws were first manufactured in 1956 by Piaggio, and were based on the Vespa scooter. For Bond's speedy tuk-tuk, stunt coordinator Rémy Julienne bought an Indian-made three-wheeler and customized it to perform like a real track motorbike.

TAXI FARE

Indian tuk-tuk taxis are required by law to have a meter to calculate the fare, but not all drivers turn them on, preferring to negotiate a price.

BACK SEAT

In Bond's tuk-tuk, the passenger seat faces backwards and the rear is open. A standard tuk-tuk taxi has a rear panel and the passengers face forward.

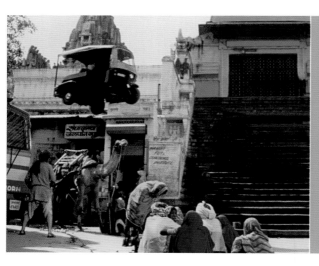

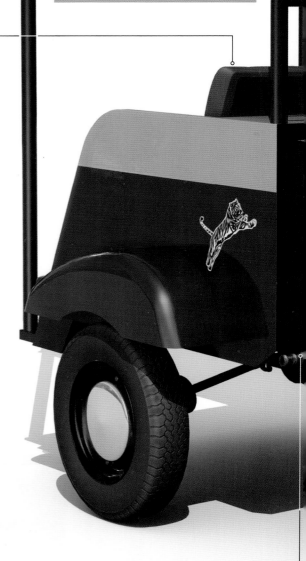

Chased by Khan's assassins, Vijay does some impressive driving while he and Bond fight off the men, with Vijay using his tennis racket. Eventually they lose them by throwing money into the crowded street, causing chaos, before driving through a secret entrance to the local Q Branch.

KICK-START

Modern rickshaws have an ignition key and starter lever, but earlier models had a kick-start pedal like a scooter.

SUNSHADE

The tuk-tuk's roof is made of water-proofed canvas, riveted to round tubing. The roof provides shade from India's fierce sun rather than shelter from rain.

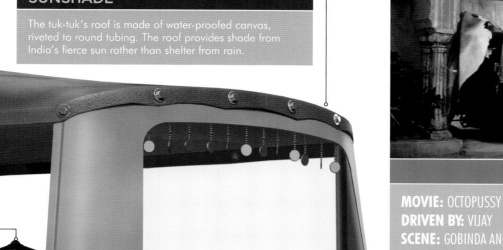

MOVIE: OCTOPUSSY
DRIVEN BY: VIJAY
SCENE: GOBINDA AND HIS MEN PURSUE VIJAY AND BOND THROUGH THE CROWDED CITY OF UDAIPUR, AND HAND-TO-HAND FIGHTING ENSUES

SCOOTER CONTROLS

Instead of a steering wheel, a tuk-tuk has handlebars with a wrist-action throttle, revealing its scooter origins and evolution.

After the chase, 007 and Vijay meet up with a disgruntled Q. He fits the stolen Fabergé egg with homing and listening devices, to be used to discover Khan's plan.

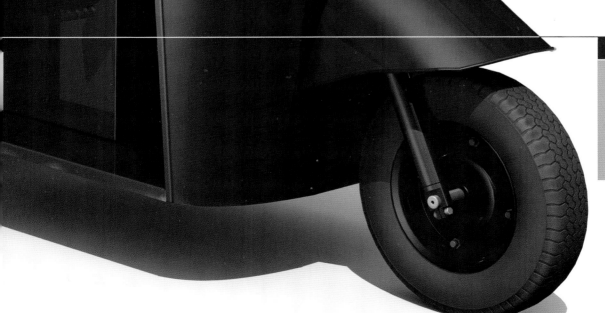

RRT 3500

ENGINE UPGRADE

A 2-stroke petrol engine delivers a top speed of 34mph (55km/h). Fortunately, Bond's tuk-tuk is fitted with a bigger powerplant, giving it a top speed of around 70mph (110km/h).

ROLLS-ROYCE S

This classic vehicle from the 1970s is the transport of choice for Bond and his fellow agent on a Central American mission.

THE LUXURY CAR is first seen driven by a hired driver before Q takes the wheel, posing as Bond's chauffeur. Bond and ex-CIA operative Pam Bouvier are working undercover in the capital of the fictional country of Isthmus, investigating local villain Franz Sanchez. Bouvier also drives the Rolls to the airport to collect her light aircraft.

A blue model features in *Licence To Kill,* and later in the franchise, for 1999's *The World Is Not Enough*, the Silver Shadow II makes another appearance in white, as a status symbol and personal vehicle of ex-KGB agent Valentin Zukovsky.

STEERING

The Silver Shadow was renamed the Silver Shadow II in 1977 in recognition of several major changes, most importantly the rack and pinion steering. Modifications to the front suspension also improved handling.

IDENTIFICATION PLATE

The boot lid carries a plate marked 'SILVER SHADOW II' to clarify that the model is the new version of the Rolls-Royce luxury vehicle.

Bond tracks Franz Sanchez to Isthmus after the drug lord maims his friend and DEA agent Felix Leiter by feeding him to sharks in Florida. 007 seeks revenge by going undercover as a 'problem eliminator', embedding himself in Sanchez's organization.

In Isthmus city, Bond travels with Bouvier in the Silver Shadow to the Hotel Mar Y Tierra, then to make a deposit at Sanchez's bank and later to the casino, where he wins big. Q also acts as chauffeur, when he picks up Bond after he has planted plastic explosives at Sanchez's residence.

ENGINE

Fitted with a 6.8-litre L410 V8 engine, with a top speed of 118mph (190km/h), the Silver Shadow II was more than just a stylish-looking car. It had been subjected to extensive wind-tunnel testing and modified to give much better stability at high speed.

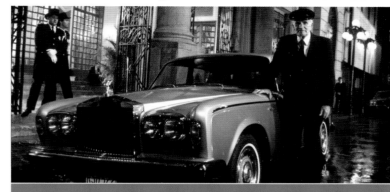

MOVIE: LICENCE TO KILL
DRIVEN BY: Q AND PAM BOUVIER
SCENES: DRIVING BOND AROUND ISTHMUS CITY IN CENTRAL AMERICA

'RR' BADGE

In 1979, 75 Silver Shadow II cars were specially fitted to commemorate the 75th anniversary of Rolls-Royce. The original red 'RR' badges were placed at the front and rear, as well as other details.

RSD 522
ISTHMUS · CITY

FOG LIGHTS

Two more new features on the Silver Shadow II were fog lights and an air dam below the bumper.

FRONT SKIRT

Outside North America, where tall kerbs demanded more ground clearance, a front skirt was fitted to the Silver Shadow II.

Joining 007 in Isthmus, Q gives Bond plastic explosives disguised as toothpaste and a gun masquerading as a camera. Bond uses these Q Branch weapons in an unsuccessful attempt to assassinate Sanchez. 007 eventually kills Sanchez using Leiter's lighter to set him on fire.

CHEVROLET CO

Coming ashore after investigating industrialist Max Zorin's oil pumping station, Bond teams up with KGB agent Pola Ivanova, as they meet by her Chevrolet C4 Corvette.

IVANOVA AND FELLOW AGENT Klotkoff have infiltrated Zorin's oil rig, where he plants a limpet mine and she records the master criminal's conversation with his team. Bond is investigating at the same time and he sets off the alarm. Klotkoff is caught and dropped into the propeller-driven intake pipe. Ivanova escapes and swims ashore where she finds Bond. They recognize each other from a previous encounter, and Ivanova wastes no time in whisking them both away from danger, gunning her Corvette's V8 engine for a swift getaway from Zorin's men.

CRASH PROTECTION

The steering column is collapsible in the event of a head-on collision, while the passenger-side dashboard features a large protective pad known as the 'breadbox'.

Ivanova is detailed to spy on Zorin as he is KGB-trained but has gone rogue.

BONNET RESTYLE

Signature pop-up headlights are restyled as single square units. The bonnet is a large clamshell design, lifted off to access the engine.

AERODYNAMIC DESIGN

Weight is reduced by more than 110kg from the previous generation by making the car slightly smaller. The aerodynamic lines improve performance and handling.

CORVETTE

RVETTE

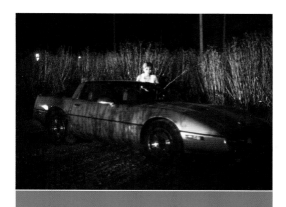

REMOVABLE ROOF

Unlike previous Corvettes, which had a T-bar roof, this model has a one-piece fibreglass panel. It can be removed with a spanner for open-topped motoring.

MOVIE: A VIEW TO A KILL
DRIVEN BY: POLA IVANOVA
SCENE: KGB AGENT IVANOVA ESCAPES WITH BOND FROM ZORIN'S PUMPING STATION NEAR SAN FRANCISCO

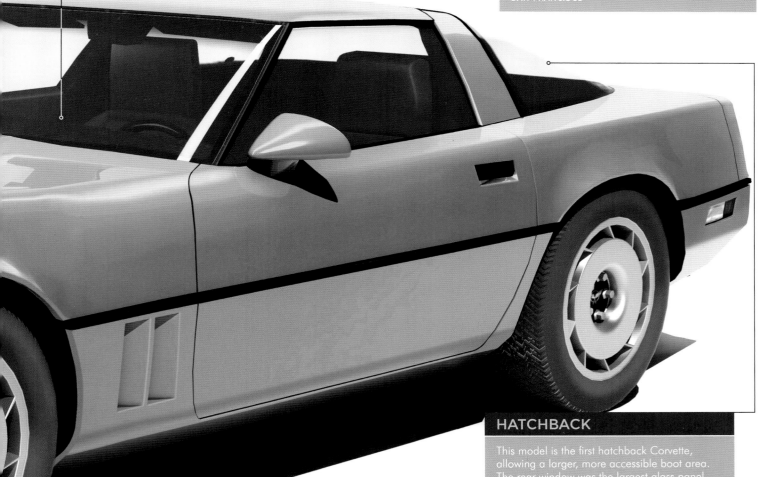

HATCHBACK

This model is the first hatchback Corvette, allowing a larger, more accessible boot area. The rear window was the largest glass panel ever installed in a US car at the time.

MONSTER TYRES

Derived from Goodyear's F1 rain tyres, the Corvette's 'Gatorbacks' have a uni-directional tread and give plenty of grip at high speeds.

Ivanova escapes Zorin's oil rig with the tape recording intact, and Bond manipulates a situation to acquire it without her being aware. The recording sets 007 on the trail of Stacey Sutton, a state geologist, who has sold her family oil business to Zorin for $5 million.

LAND ROVER DI

The much-loved classic 4x4 landed the starring part in the bruising, relentless car chase in *Skyfall*'s pre-title sequence — and delivered a mesmerizing performance worthy of the British field agents.

EVE MONEYPENNY, at the wheel of the Defender with Bond as her passenger, pursues the Audi A5 driven by villain Patrice through the narrow streets and bazaars of Istanbul. Their mission is to retrieve a hard drive of classified data that Patrice has stolen. When the Audi is turned on its side in the midst of open-air market stalls, Patrice and Bond take to the rooftops on motorbikes, still followed by Eve in the Defender.

After leaping from a bridge, Patrice and Bond launch into a fight on the roof of a train, using guns, a digger and fists. Eve drives the Land Rover alongside the train, before stopping to fire her sniper rifle. Aiming at Patrice but without a clear shot, she hits Bond who falls off a bridge to the water below, as Patrice escapes into a tunnel.

007 is 'missing, presumed dead' but survives and returns to London after hearing of an attack on the MI6 headquarters.

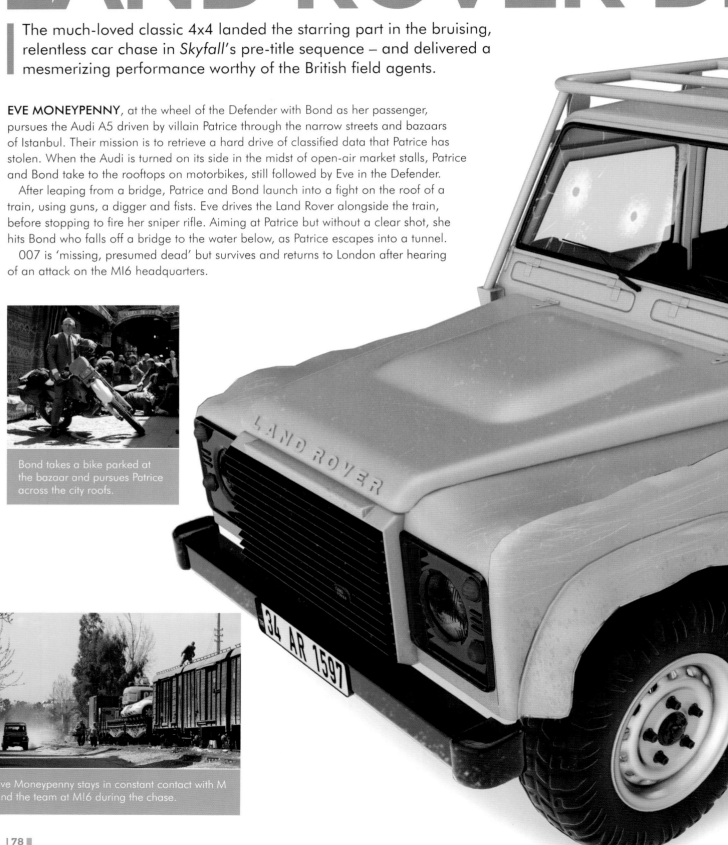

Bond takes a bike parked at the bazaar and pursues Patrice across the city roofs.

Eve Moneypenny stays in constant contact with M and the team at MI6 during the chase.

FENDER 110

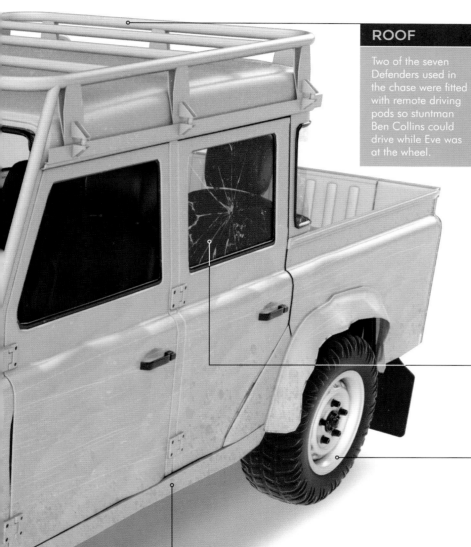

ROOF

Two of the seven Defenders used in the chase were fitted with remote driving pods so stuntman Ben Collins could drive while Eve was at the wheel.

MOVIE: SKYFALL
DRIVEN BY: EVE MONEYPENNY
SCENE: BOND AND MONEYPENNY PURSUE PATRICE THROUGH THE CENTRE OF ISTANBUL AND ON TO A CARGO TRAIN HEADING OUT OF THE CITY

INTERIOR ADJUSTMENTS

Some vehicles were fitted with interior roll cages to give stunt drivers added protection.

WHEELS

The heavy-duty steel wheels on the stunt cars were spread to give greater stability.

MODEL

The Defender Double Cab 110 in Stornoway Grey Metallic was named after its design and the 110-inch long wheelbase.

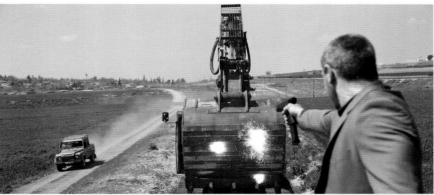

Moneypenny drives on the dirt road alongside the cargo train, as Bond sets a Caterpillar hydraulic excavator in motion to gain on the mercenary Patrice.

ASTON MARTIN DE

A mixture of beauty and brawn, with stunning looks and a top speed of 211mph, the Superleggera is the next evolution of Bond car from Aston Martin.

In *NO TIME TO DIE*, **THE DBS SUPERLEGGERA** is the MI6 vehicle issued to agent 003, Nomi. Nomi and Bond drive it to a NATO airfield in Norway and pull up alongside a C-17 cargo plane, where Q is already on board. The three take off to launch a mission against the villain Safin.

The DBS Superleggera (Superleggera, the Italian for 'Superlight' and named in honour of Italian coachbuilding firm Carrozzeria Touring) was revealed in 2018 and is the marque's V12 flagship grand tourer. Reviving the DBS nameplate, last seen in 2012, and harking back to the original DBS from 1967, this is a 'super' GT that draws on the best from the automaker's past while looking firmly forward.

POWERFUL ENGINE

With a 5.2-litre twin-turbo V12 engine that gives the car 715 horsepower, the DBS Superleggera has a 0–62mph in less than 3.6 seconds. It can reach 100mph in just 6.4 seconds. This V12 engine has more power and torque than any full series-production Aston Martin to date.

ENGINE COOLING

The front of the DBS Superleggera features a new front bumper with a large centre grille for improved engine cooling, along with two air extractors on the side to cool the brakes and two vents on the bonnet to aid in the engine-cooling process.

SUPERLEGGERA

DRIVING MODES

The DBS Superleggera has three driving modes which adjust the responsiveness of the car: GT, Sport and Sport Plus.

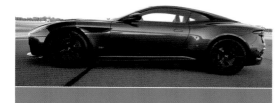

MOVIE: NO TIME TO DIE
DRIVEN BY: NOMI
SCENE: RENDEZVOUS WITH BOND IN NORWAY

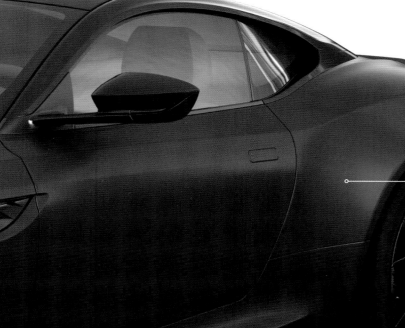

BODY

Made mostly of carbon fibre, the DBS Superleggera body is lighter than its predecessor, at 1,693kg (3,732lb).

The Superleggera is assigned to Nomi, agent 003.

AERODYNAMICS

Featuring the aerodynamics first used on the DB11, with Aston Martin's innovative Aeroblade system, the DBS Superleggera includes a Formula 1-inspired double-diffuser that helps the car generate 180kg (397lb) of downforce – the highest figure ever for a series production Aston.

EXHAUST SYSTEM

A new quad-pipe titanium exhaust system with active flaps ensures improved engine sound, as the V12 sprays extra fuel into the pipes for pops and bangs on throttle-lift.

81

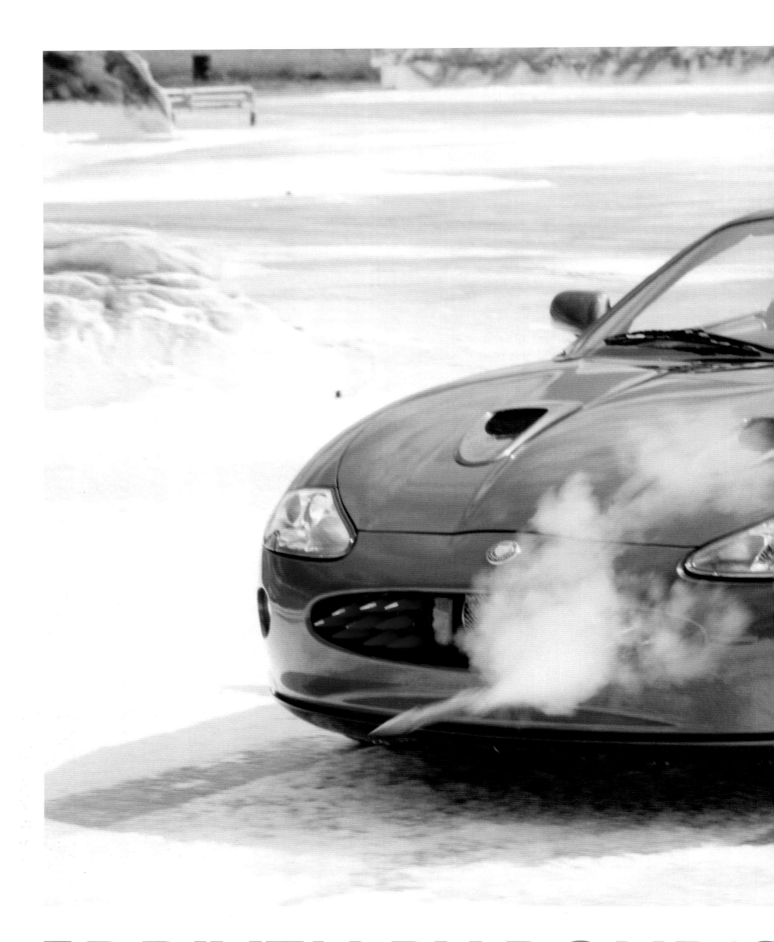

DRIVEN BY BOND'S

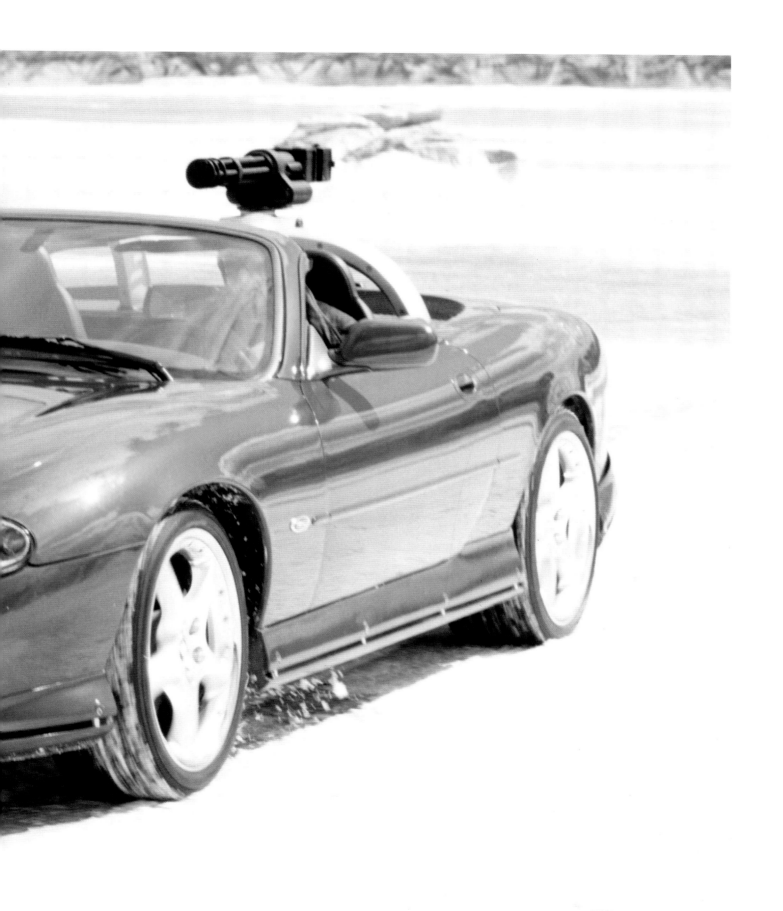

ENEMIES

▮ROLLS-ROYCE

▮ Auric Goldfinger might not be a man that James Bond respects, but he knows his cars. His Phantom III is the ultimate prestigious motor with an ingenious use.

SIX TIMES A YEAR, Auric Goldfinger takes a trip across Europe in his beautiful, classic 1937 Rolls-Royce Phantom III. The reason for this is that the car's bodywork has been replaced by 18-carat gold and once the car leaves Britain and reaches his factory in Switzerland, the gold is smelted down into approximately two tons of gold bullion. The great strength of the Phantom III made it able to carry the weight of the hidden gold with ease.

Notably, the automobile has the licence plate 'AU 1'. Au is the symbol on the periodic table for the element gold, named after the Latin word for gold: *aurum*.

DRIVER'S CABIN

Oddjob drives the 1937 Phantom III from this separate open-top chauffeur's cabin, while his employer, Goldfinger, travels in the luxurious closed cabin behind.

DOOR PANELS

Made of solid gold, the panels are so heavy that it takes two people to remove them from their rear hinges. Once in Goldfinger's plant, the panels are melted down.

Goldfinger has a secret plan to increase the value of his gold by irradiating all the bullion in Fort Knox, USA. He is under suspicion by MI6, so Bond visits Goldfinger at his country club – and slips a tracking device in the boot of his Rolls-Royce.

Bond follows Goldfinger to his Swiss base, where he sees the Rolls-Royce being dismantled, and the gold parts melted down and poured into moulds to make ingots.

ENGINE

Rolls-Royce's first V12 engine was aluminium and had exceptional power. A second would not appear until 1998. In Goldfinger's car, some of the larger engine parts are cast in gold, so they can be smuggled underneath the bonnet.

PHANTOM III

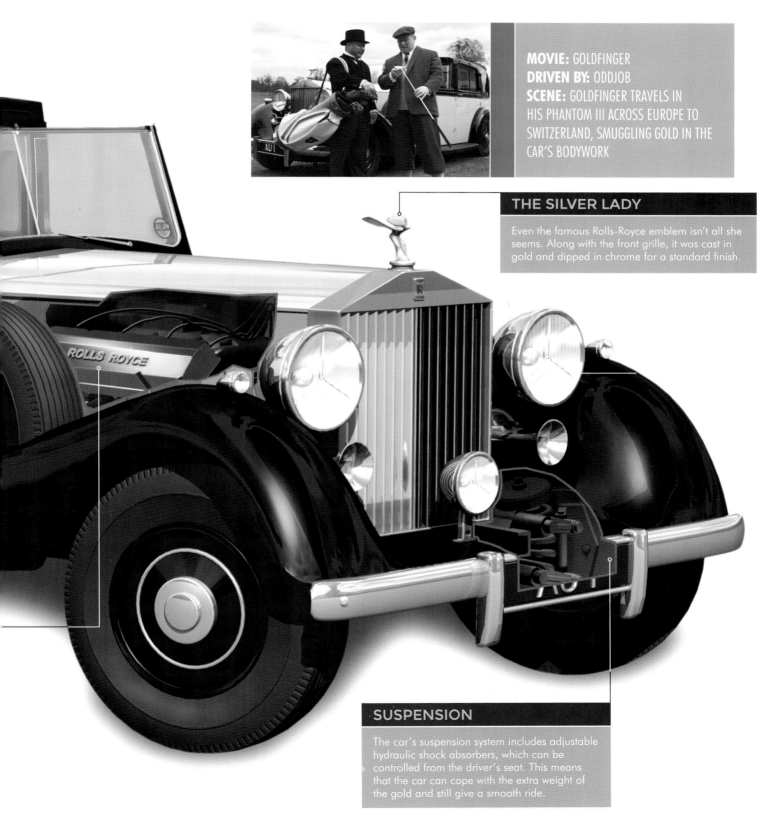

MOVIE: GOLDFINGER
DRIVEN BY: ODDJOB
SCENE: GOLDFINGER TRAVELS IN HIS PHANTOM III ACROSS EUROPE TO SWITZERLAND, SMUGGLING GOLD IN THE CAR'S BODYWORK

THE SILVER LADY

Even the famous Rolls-Royce emblem isn't all she seems. Along with the front grille, it was cast in gold and dipped in chrome for a standard finish.

SUSPENSION

The car's suspension system includes adjustable hydraulic shock absorbers, which can be controlled from the driver's seat. This means that the car can cope with the extra weight of the gold and still give a smooth ride.

FORD FALCON R

Oddjob chauffeurs mobster Mr. Solo and his gold bullion in a Lincoln Continental to the 'airport'. He returns in a Falcon Ranchero with a grisly load: a crushed metal cube comprising the Lincoln, Mr. Solo and the gold.

AURIC GOLDFINGER HAS REVEALED Operation Grand Slam, his plan to take control of Fort Knox, to a group of mobsters who have loaned him money. Mr. Solo wants no part in it, so elects to leave with his repaid loan. Felix Leiter tails the car but loses their coordinates, because the Lincoln has disappeared into the jaws of a scrapyard crusher. Enter the Ranchero, driven by Oddjob, to transport the mangled remains back to Auric Stud Farms, Inc.

The first generation Ford Ranchero exclaimed in its adverts to be 'More than a car! More than a truck!' The second generation Falcon Ranchero was produced by Ford from 1960 to 1965. It was a smaller, lighter and cheaper variation on the original Ranchero utility vehicle, which Ford believed would have a wider appeal. Ford redesigned the Falcon Ranchero in 1964 and provided brand new vehicles for the filming of *Goldfinger*.

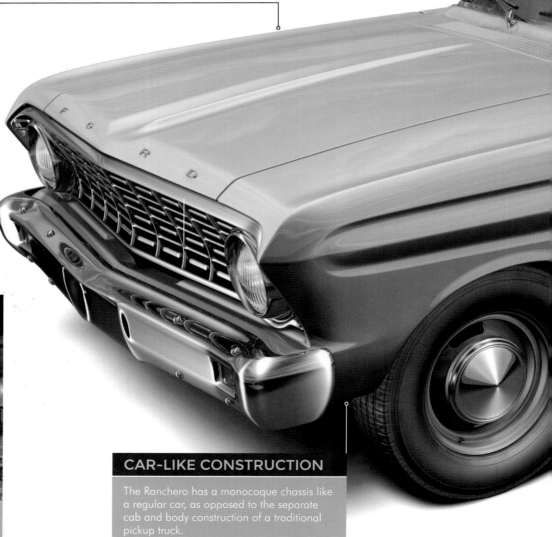

BIG BLOCK ENGINES

Four engines are available for this Ranchero – a 170-cubic inch drivetrain that gives 105bhp was standard, while an optional 200-cubic inch motor ups the power to 120bhp. The 260-cubic inch V8 motor was replaced by the 289-cubic inch motor in 1965. The two-barrel carburettor version produced 200bhp and the four-venturi version gave 225bhp.

Auric Goldfinger reveals his plans, but Mr. Solo, centre, is not impressed.

CAR-LIKE CONSTRUCTION

The Ranchero has a monocoque chassis like a regular car, as opposed to the separate cab and body construction of a traditional pickup truck.

ANCHERO

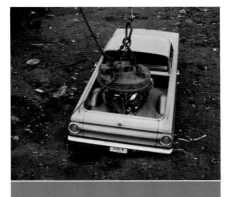

COMFY CAB

The roomy cab has the style and comfort of the Falcon passenger car on which this generation of Ranchero is based.

Oddjob: all-round fixer for Goldfinger.

AURIC STUD FARMS, INC.
LOUISVILLE, KY.

OPTIONAL EXTRAS

The range of options is extensive for a pickup and includes power steering, air conditioning, padded dash and visors, seat belts, three different types of wheel cover, push-button radio, two-speed wipers and white sidewall tyres.

Bond is released from confinement on the farm and knows of Goldfinger's impending assault on Fort Knox. To stop this, Bond needs to enlist the help of Pussy Galore and her team.

The scrapyard crusher completes its job on Mr. Solo's car, ready for Oddjob to collect.

FORD COUNTRY

One of the vehicles at Goldfinger's stud farm is a Ford Country Squire. This versatile vehicle is used by Oddjob to pick up Bond from the airfield when he arrives from Europe.

LOAD HAULER

Ever mindful of their customer profile, Ford designed the second and third rows of seating to fold down, creating a cargo area more than three metres long.

AFTER BOND HAS ESCAPED death-by-laser, he is tranquillized and transported to the US on Goldfinger's plane. He recovers consciousness en route, but is held at gunpoint by the pilot, Pussy Galore. On landing she hands over Bond to a reception party of Oddjob and two more of Goldfinger's men who have come to meet him in the Auric Stud Farms' Ford Country Squire.

There are three rows of seating in the Country Squire. Bond is seated in the second row covered by men in the third row, while Oddjob is at the wheel.

Oddjob – Goldfinger's manservant and chauffeur – travels with him all over the world. He doesn't speak, but carries out Goldfinger's orders with extreme efficiency.

ENGINE OPTIONS

During the 1960s, the Country Squire had a choice of five engines: one straight six-cylinder powerplant that was designed for economy and four powerful V8 engines. These were mated to either a four-speed manual gearbox or a three-speed automatic.

SQUIRE

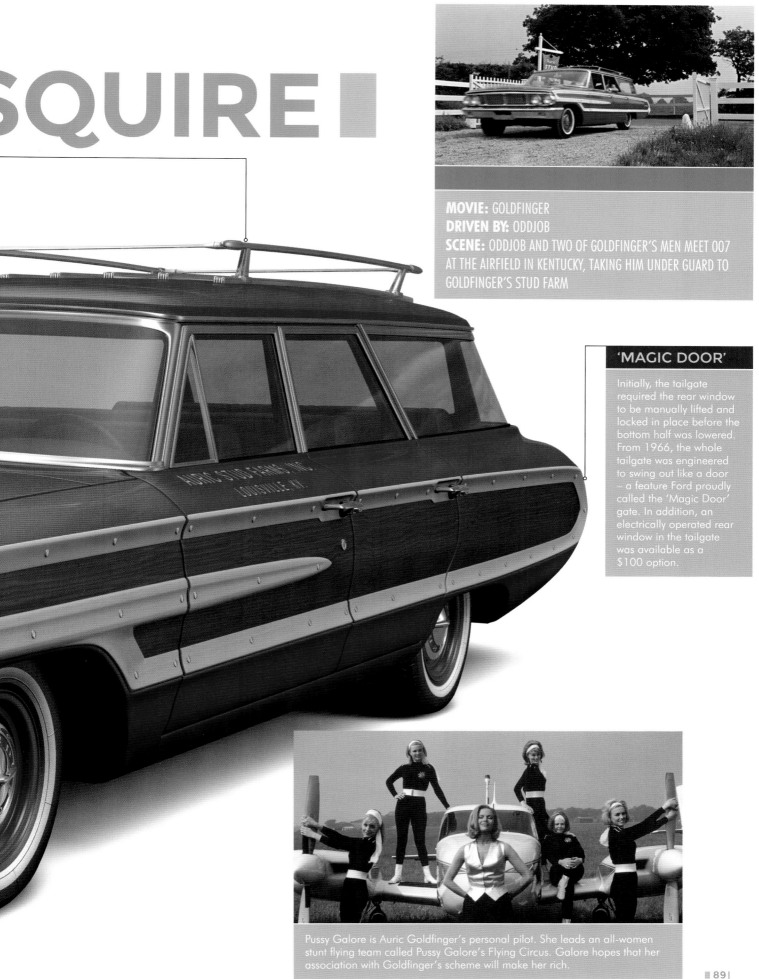

MOVIE: GOLDFINGER
DRIVEN BY: ODDJOB
SCENE: ODDJOB AND TWO OF GOLDFINGER'S MEN MEET 007 AT THE AIRFIELD IN KENTUCKY, TAKING HIM UNDER GUARD TO GOLDFINGER'S STUD FARM

'MAGIC DOOR'

Initially, the tailgate required the rear window to be manually lifted and locked in place before the bottom half was lowered. From 1966, the whole tailgate was engineered to swing out like a door – a feature Ford proudly called the 'Magic Door' gate. In addition, an electrically operated rear window in the tailgate was available as a $100 option.

Pussy Galore is Auric Goldfinger's personal pilot. She leads an all-women stunt flying team called Pussy Galore's Flying Circus. Galore hopes that her association with Goldfinger's scheme will make her rich.

DRAGON TANK

Bond is on the trail of Dr. No, believing him to be behind the radio jamming of US rocket launches. A local fisherman, Quarrel, helping the CIA, tells Bond stories of a dragon on Crab Key island – and then they meet it!

IT TAKES SOME EFFORT on the part of 007 to convince Quarrel to return to Crab Key island, but the fisherman does eventually agree to help the British agent. Meeting Honey Ryder along the way, they cross a swamp when a voice booms out ordering them to stay right where they are. The trio hear a motor power up and in the distance, the Dragon Tank comes towards them, spitting out huge balls of flame. Bond decides to go for the headlights and tyres, and Quarrel can take out the driver. Under cover, Quarrel and 007 fire at their targets, but with limited success – it's just too dark. All of a sudden, Quarrel discovers he's far too close as a massive jet of flame pours out of the tank's flamethrowers and he's burned alive. Bond and Honey are apprehended by the tank crew and taken to a compound.

DRAGON PAINTING

The paint on the body of the tank is dark green to look like dragon's scales. The 'eyes' and the 'teeth' are painted white to stand out at night.

FLAME THROWERS

Powerful flames shoot out several feet from either side of the tank, as if blasting from a dragon's nostrils.

RAZOR-LIKE 'TEETH'

The metal armour at the front of the tank is shaped into sharp, jagged 'teeth' to enhance the tank's mythical dragon-like appearance.

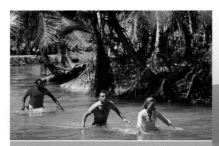

Quarrel, Bond and Honey make their way across the island through water to hide their scent from guard dogs.

ARMED GUARDS

Dressed in full radiation suits, Dr. No's guards are safe from any harmful rays emitted from Crab Key's nuclear reactor. One of the guards surprises Bond and Honey by appearing from the tank parapet.

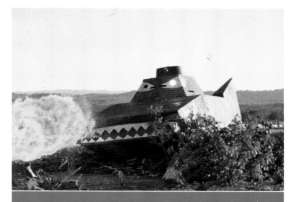

Bond and Honey attempt to hide from the flame-throwing machine.

MOVIE: DR. NO
DRIVEN BY: DR. NO'S MEN
SCENE: A PLOY TO SCARE LOCALS AWAY, THE DRAGON TANK ALSO KILLS QUARREL AND CAPTURES BOND AND HONEY

HEADLIGHTS

The tank's lights are meant to look like eyes – Bond shoots one of the lights out as the tank rolls towards him and Honey.

ARMOUR PLATING

The inner workings of the tank are protected by steel plating. This means that the dragon tank can easily deflect any gunfire.

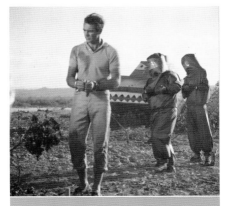

Bond and Honey Ryder are rounded up by Dr. No's henchmen.

FORD FAIRLANE

Count Lippe makes a second attempt to assassinate 007 by shooting at him from his Ford Fairlane 500 Skyliner – before he and his car meet an explosive end.

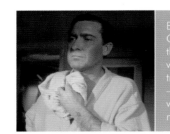

Bond first meets Count Lippe at the health farm, where Lippe tries – and fails – to kill 007 with a traction machine.

AFTER BOND LEAVES the Shrublands health farm in his Aston Martin DB5, SPECTRE operative Count Lippe follows in his Ford Fairlane Skyliner and shoots at him. Before Bond can retaliate, a BSA Lightning motorcycle rider speeds up and fires two missiles, blowing up the Ford and killing Lippe. It is revealed that the motorcyclist is SPECTRE assassin Fiona Volpe, acting on Blofeld's orders.

The scene in *Thunderball* was filmed on the racing circuit at Silverstone in Northamptonshire. A 1957 Ford Fairlane Skyliner is briefly driven by Bond around Cuba in 2002's *Die Another Day*.

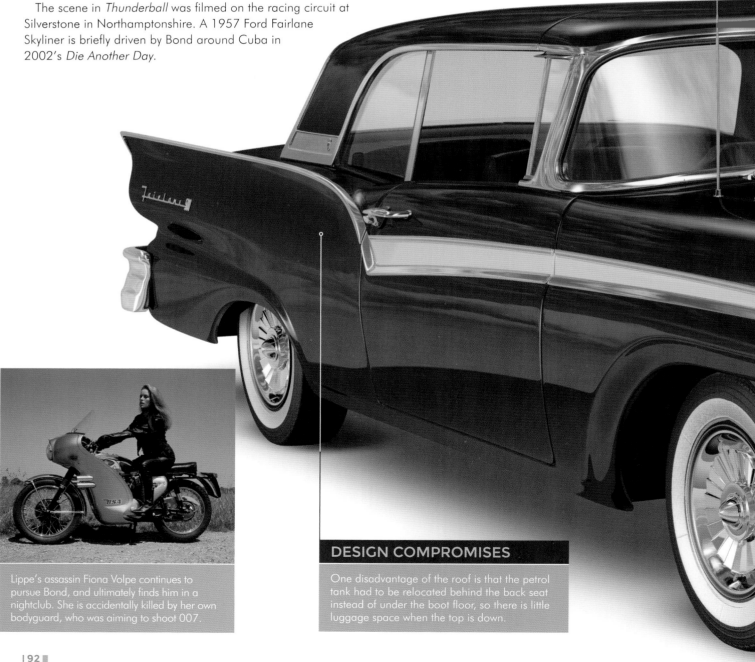

Lippe's assassin Fiona Volpe continues to pursue Bond, and ultimately finds him in a nightclub. She is accidentally killed by her own bodyguard, who was aiming to shoot 007.

DESIGN COMPROMISES

One disadvantage of the roof is that the petrol tank had to be relocated behind the back seat instead of under the boot floor, so there is little luggage space when the top is down.

Count Lippe was part of a plot by SPECTRE operative Number Two Emilio Largo to extort £100,000,000 from NATO by threatening them with stolen atomic bombs.

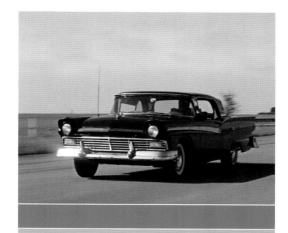

FOLDING HARDTOP

The Skyliner has a folding roof as an option. In an era of 'space-age' design it proved to be a sensation and customers flocked to showrooms to view the roof.

EXPLOSIVE ADDITION

A modified Fairlane was used for the scene in *Thunderball* where it was blown up. A polythene bag was filled with wads of felt soaked in petrol and placed in a metal tray in the boot. As a result, the boot lid was blown off and the car exploded in flames.

MOVIE: THUNDERBALL
DRIVEN BY: COUNT LIPPE
SCENE: EN ROUTE TO LONDON, BOND ESCAPES ASSASSINATION BY LIPPE WHEN A MYSTERY MOTORCYCLIST BLOWS UP LIPPE'S CAR

GEARBOX OPTIONS

In 1957, there was a choice of six engines, each available with any one of three gearboxes: a column-shift three-speed manual, the same with overdrive, or a Fordomatic two-speed automatic.

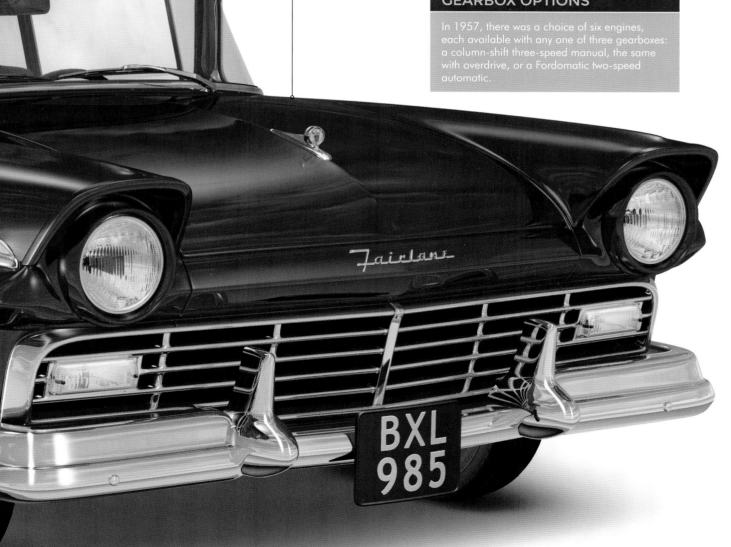

CADILLAC HEA

Undercover as a diamond smuggler in league with SPECTRE supremo Ernst Stavro Blofeld, 007 is an unwilling passenger in a hearse… that's taking him to his own funeral.

DISGUISED AS SMUGGLER PETER FRANKS, Bond picks up the casket containing the body of the real Franks when he lands at Los Angeles airport. He's met by three heavies, who are eager for Bond to join them in their hearse for the drive to the Slumber Inc. crematorium, which is a front for part of the smuggling operation. When they arrive, Bond is knocked out by Blofeld's assassins, Wint and Kidd. He comes round inside a coffin but avoids being cremated alive because the diamonds he smuggled inside Franks' body have been exchanged for fakes. He is rescued by smugglers Morton Slumber and Shady Tree, who demand the real diamonds. As 'Franks' was paid with counterfeit money, Bond tells them that when he gets the real cash, they'll get the real diamonds.

This isn't Bond's first run-in with a hearse in the 007 film franchise. In 1962's *Dr. No*, his Sunbeam Alpine is chased in Jamaica by assassins in a 1939 LaSalle Funeral Coach, with Dr. No's men eventually plunging off a cliff to their deaths.

NAME CHECK

Cadillac has always maintained its position as a leading luxury car manufacturer in the United States. Its distinctive styling has made the car a movie icon.

STYLING

Once pulled by horses until the introduction of the motor engine, hearses still follow – out of necessity – the same design. The modern motorized hearse has maintained this classic design since the 1960s, with very little difference in detail.

EMBLEM

This script 'Cadillac' is the very first emblem used by the car manufacturer. Following World War II, Cadillac adopted the 'V' logo to symbolize the V-8. Many variations on this theme followed, although the 'V' didn't last much after 1968.

RSE

LONG-SERVING

Because of their low mileage and relatively low usage, such hearses have exceptionally long lives – many can be 30 years old and still in regular use.

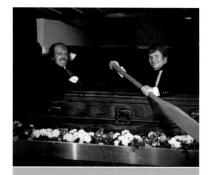

Mr. Wint and Mr. Kidd send Bond to a fiery death – or so they think.

MOVIE: DIAMONDS ARE FOREVER
DRIVEN BY: SLUMBER INC. GANGSTER
SCENE: BOND IS DRIVEN FROM LOS ANGELES AIRPORT TO SLUMBER INC. IN LAS VEGAS, SURROUNDED BY THREE GANGSTERS

MODIFICATIONS

The Cadillac Commercial Chassis, based on the Cadillac Fleetwood limousine, is much lower than that of a passenger car, for ease of loading and unloading caskets. The chassis of the hearse is also stronger.

CAR CONTROLS

The Cadillac chassis were shipped to coachbuilders with little more than lighting, dashboard, air conditioning and the main road controls. The rest was constructed and assembled by the particular coachbuilder.

Head of SPECTRE Ernst Stavro Blofeld plans to create a space laser with stolen diamonds that will destroy the world's nuclear weapons – so he can hold the world to ransom.

▮CORVORADO ▮

Bond may not drive his own car in *Live And Let Die*, but the movie still boasts an automobile – Whisper's Corvorado – with film star looks and a lethal secret weapon.

BOND IS PICKED UP from the airport in New York by an undercover CIA agent. In transit the unlucky agent is killed by Dr. Kananga/Mr. Big's assassin Whisper, with a secret weapon from his Corvorado that almost kills 007 too.

The early 1970s were the heyday of the pimpmobile – an extravagantly customized car – and Whisper's 'tricked out' Corvorado is a beautiful example of the breed. Produced by coachbuilders Dunham Coach of New Jersey, the customizing on this car is extraordinary.

DASHBOARD TARGETING

To target the dart gun – the car's secret weapon – a dashboard video screen relays images shot from a miniature camera in the wing mirror.

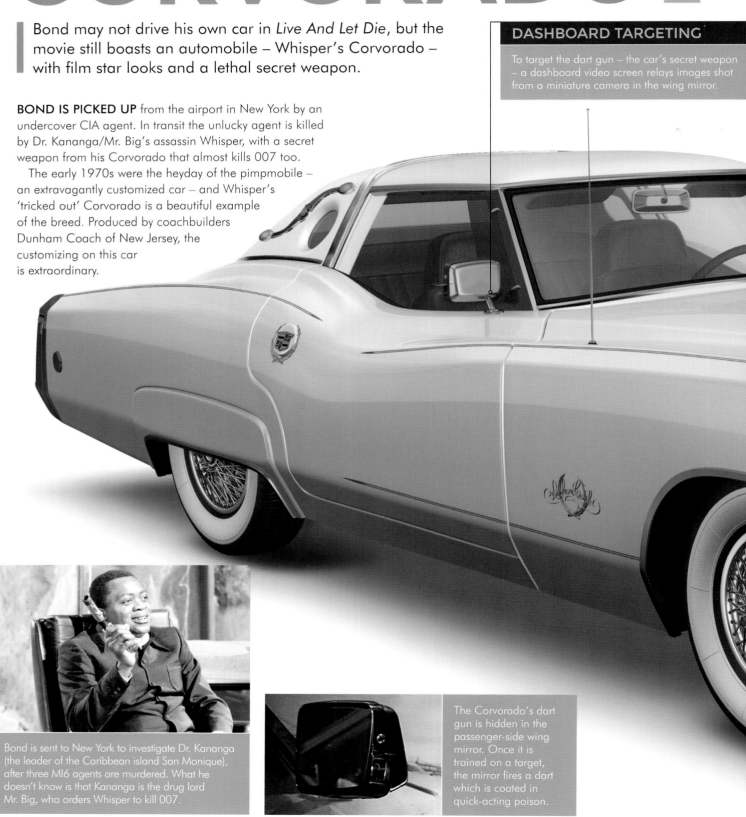

Bond is sent to New York to investigate Dr. Kananga (the leader of the Caribbean island San Monique), after three MI6 agents are murdered. What he doesn't know is that Kananga is the drug lord Mr. Big, who orders Whisper to kill 007.

The Corvorado's dart gun is hidden in the passenger-side wing mirror. Once it is trained on a target, the mirror fires a dart which is coated in quick-acting poison.

Whisper: killer henchman of Harlem's Mr. Big.

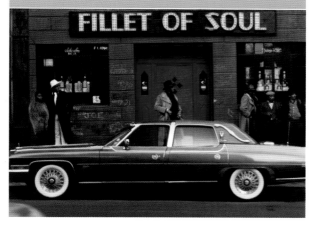

With the CIA's help, Bond traces the Corvorado to a Voodoo shop in Manhattan. He then follows another car to the Fillet of Soul club in Harlem, which turns out to be one of Mr. Big's bases.

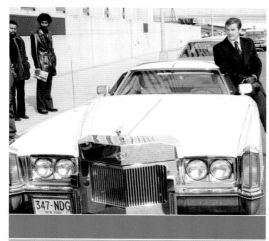

MOVIE: LIVE AND LET DIE
DRIVEN BY: WHISPER
SCENE: IN NEW YORK, BOND'S DRIVER IS KILLED BY A POISONED DART FROM WHISPER'S CAR. BOND HIMSELF NARROWLY ESCAPES

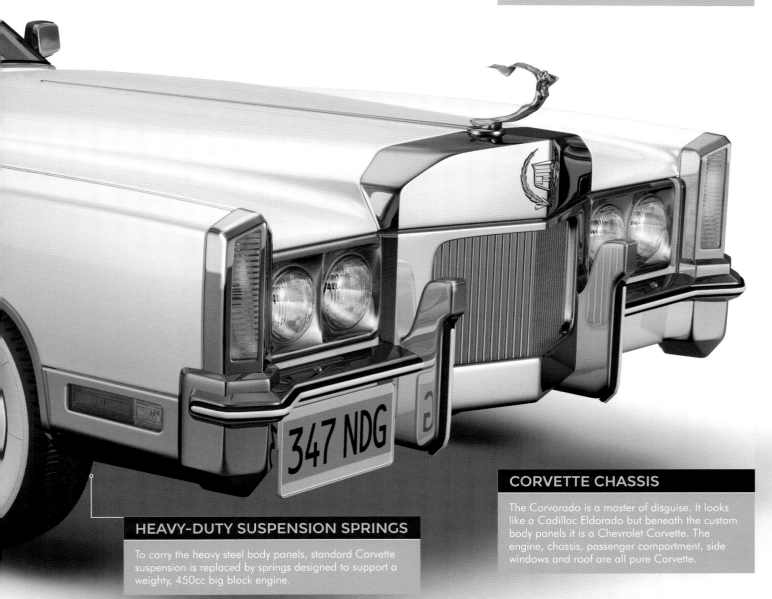

HEAVY-DUTY SUSPENSION SPRINGS

To carry the heavy steel body panels, standard Corvette suspension is replaced by springs designed to support a weighty, 450cc big block engine.

CORVETTE CHASSIS

The Corvorado is a master of disguise. It looks like a Cadillac Eldorado but beneath the custom body panels it is a Chevrolet Corvette. The engine, chassis, passenger compartment, side windows and roof are all pure Corvette.

AMC MATADOR

Scaramanga has a unique way of giving Bond the slip in Thailand. Amazingly, his Matador Coupé converts into a flying car and he flies back to his private island hideaway.

FRANCISCO SCARAMANGA AND NICK NACK use a 1974 AMC Matador Coupé to kidnap Mary Goodnight, before being pursued by Bond in a high-speed chase through the streets and countryside of Thailand. Scaramanga drives the stylish Matador into an old warehouse, where a wing and flight-tail module is attached to the roof. He then accelerates and takes off, watched in disbelief by Bond and the Thai police.

Agent Goodnight places a tracking device in the Matador, but she is spotted and pushed into the boot by Scaramanga.

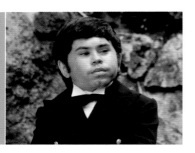

Nick Nack is Francisco Scaramanga's henchman: a clever, impeccably dressed private assistant who serves as butler, chef, driver — and killer.

WINGS AND FLIGHT-TAIL

This module is hidden away in a warehouse and then attached to the sides of the car with struts, turning it into the ultimate getaway vehicle.

HEADLIGHTS

The round, deeply 'tunnelled' headlights are one of the most distinctive features of the Matador Coupé. Their shape is echoed in the circular taillights.

INDICATORS

The grille features round indicators, which are styled to resemble the headlights. In 1976, these indicators were redesigned to be square units.

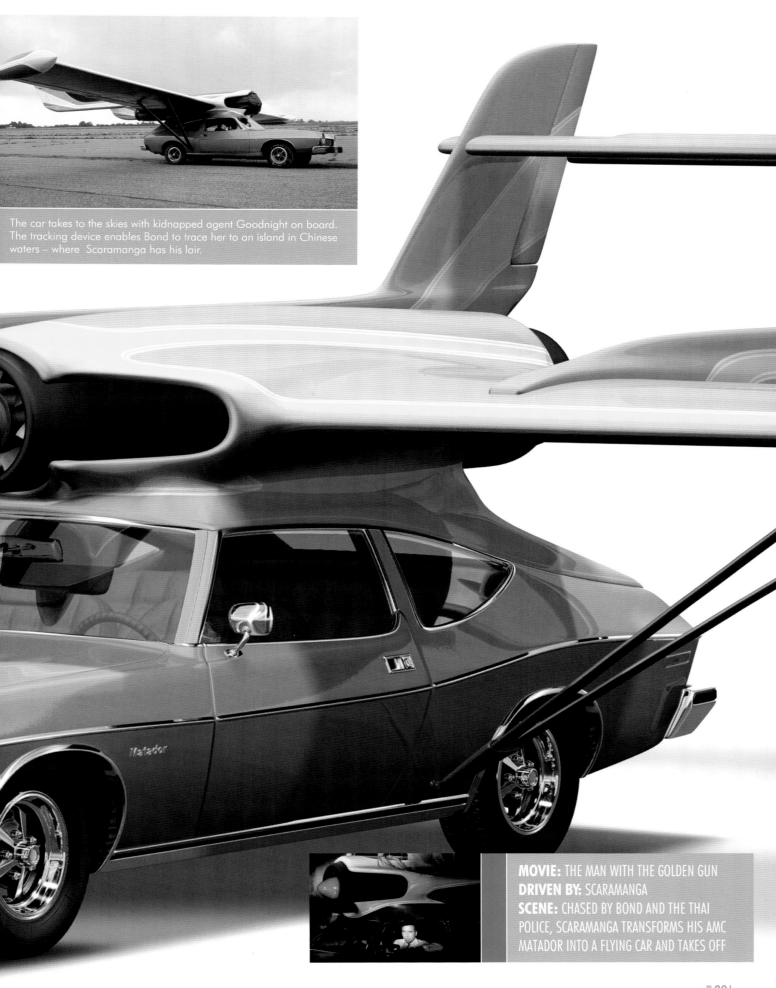

The car takes to the skies with kidnapped agent Goodnight on board. The tracking device enables Bond to trace her to an island in Chinese waters – where Scaramanga has his lair.

Matador

MOVIE: THE MAN WITH THE GOLDEN GUN
DRIVEN BY: SCARAMANGA
SCENE: CHASED BY BOND AND THE THAI POLICE, SCARAMANGA TRANSFORMS HIS AMC MATADOR INTO A FLYING CAR AND TAKES OFF

GP BEACH BUGG

When Colombo's mistress and Bond are observed sharing information, Kristatos sends his men to her beachfront house to deal with them. They arrive in beach buggies with the aim of running down their prey.

AFTER BOND SPENDS the night with Countess Lisl, the pair go for a dawn stroll on the beach. They hear the ominous sound of revving engines before several beach buggies come flying over the sand dunes. Bond draws his gun and manages to shoot out the tyre on one of the buggies so it loses control and flips over. Meanwhile, the Countess has fled in panic, and a second buggy driven by the impassive psychopath, Emile Locque, ruthlessly runs her down, killing her instantly. As Bond watches helplessly, another beach buggy nearly knocks him down, but he manages to leap out of the way at the last moment. The driver points a gun at 007 and ushers him towards Locque who has pulled up beside them. Just as it looks as if Bond will be executed, some of Colombo's men arrive and shoot the henchman in the back, while Locque escapes in his beach buggy.

Like many other designs of beach buggy, the GP in the film was based on the VW Beetle. Three grey GP Super Buggies were used for filming the scene in Corfu.

BEETLE MECHANICS

The GP had a similar running gear to the VW Beetle's including the chassis, suspension, engine and electrical systems. It had a covered rear end with a removable hatch for engine access.

REAR SEATING

The GP Super Buggy was based on the full-length floorplan of the Beetle that had room for seating in the back, unlike the original buggy, which was a two-seater.

Bond meets Austrian aristocrat Countess Lisl Von Schlaf at a casino in Corfu. On an evening drive Bond tells the countess he is a writer preparing a novel about Greek smugglers. Later at her beach house Lisl confesses to being a phony countess and Bond admits to being a spy.

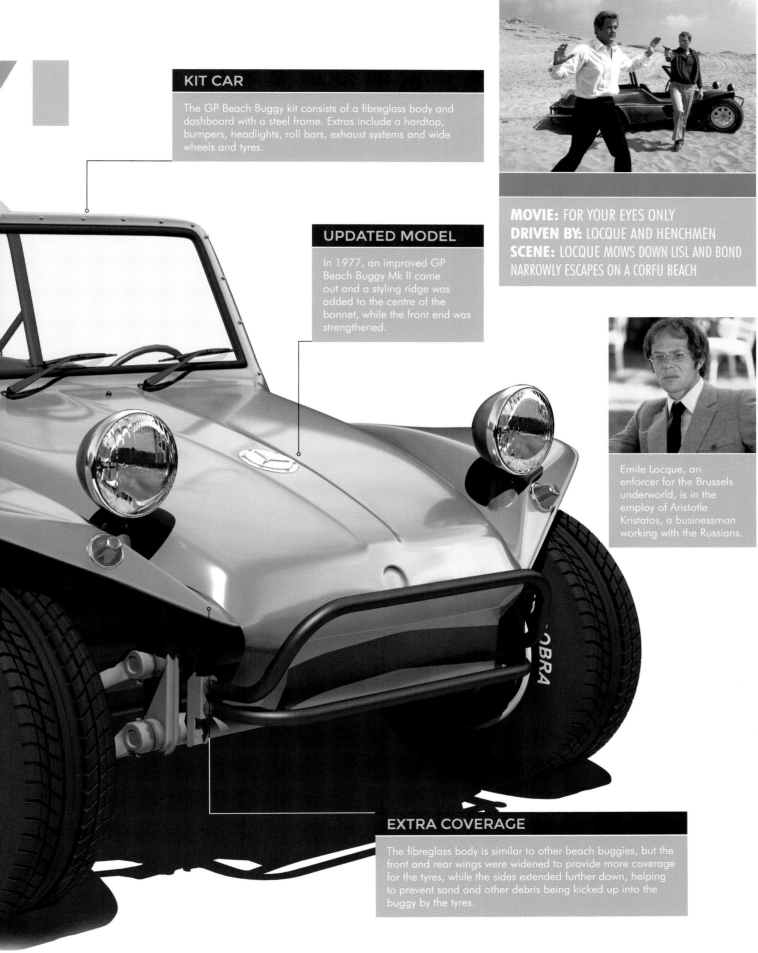

KIT CAR

The GP Beach Buggy kit consists of a fibreglass body and dashboard with a steel frame. Extras include a hardtop, bumpers, headlights, roll bars, exhaust systems and wide wheels and tyres.

UPDATED MODEL

In 1977, an improved GP Beach Buggy Mk II came out and a styling ridge was added to the centre of the bonnet, while the front end was strengthened.

MOVIE: FOR YOUR EYES ONLY
DRIVEN BY: LOCQUE AND HENCHMEN
SCENE: LOCQUE MOWS DOWN LISL AND BOND NARROWLY ESCAPES ON A CORFU BEACH

Emile Locque, an enforcer for the Brussels underworld, is in the employ of Aristotle Kristatos, a businessman working with the Russians.

EXTRA COVERAGE

The fibreglass body is similar to other beach buggies, but the front and rear wings were widened to provide more coverage for the tyres, while the sides extended further down, helping to prevent sand and other debris being kicked up into the buggy by the tyres.

FERRARI F355 G

Engaging Bond in a challenging race, Xenia Onatopp has to rely on the speed and impressive handling of her Ferrari F355 GTS. Fortunately, this is one of the greatest sports cars ever built.

FIERY RED AND HIGH PERFORMANCE, the F355 is a perfect car for ex-Soviet assassin and Janus Crime Syndicate member Xenia Onatopp. Although the Ferrari has no hidden 'extras' – bar the counterfeit number plates spotted by 007 outside Monte Carlo's casino – it is more than a match for anything else on the road, including Bond's DB5.

The legendary Ferrari factory at Maranello has turned out some of the most impressive cars in the world, and the F355 GTS is no exception, combining raw power with head-turning looks. Catching Bond's attention was easy with this magnificent car.

REMOVABLE ROOF PANEL

Xenia Onatopp's F355 is the Targa-style GTS model with removable roof panel – ideal for driving along winding hillside roads on sunny days in Monaco.

POP-UP HEADLIGHTS

To maintain its sleek, sporting lines, the Ferrari keeps its headlights under cover. The F355 was the last Ferrari model to feature retractable headlights.

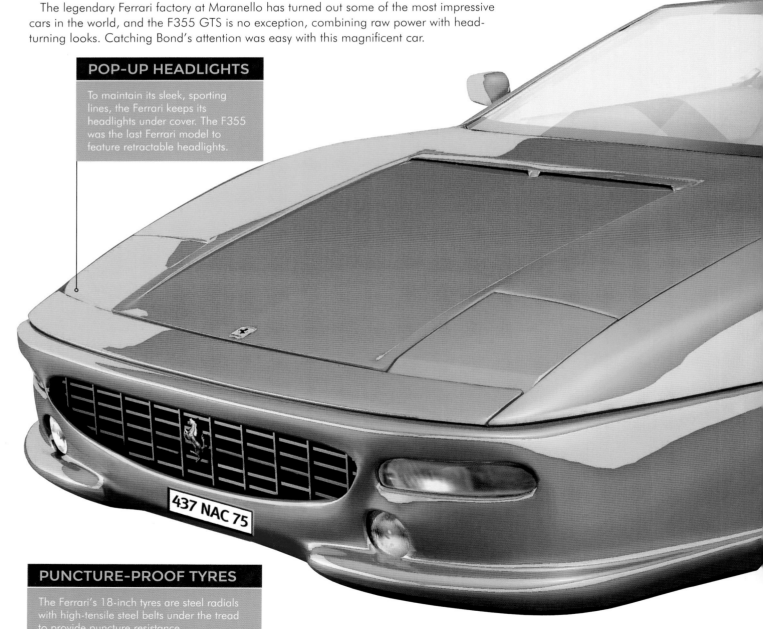

PUNCTURE-PROOF TYRES

The Ferrari's 18-inch tyres are steel radials with high-tensile steel belts under the tread to provide puncture resistance.

437 NAC 75

POWERFUL MID-ENGINE

The Ferrari F355's 3.5 litre V8 engine is positioned behind the seats and between the main axles to give the best weight distribution possible, as well as improved handling.

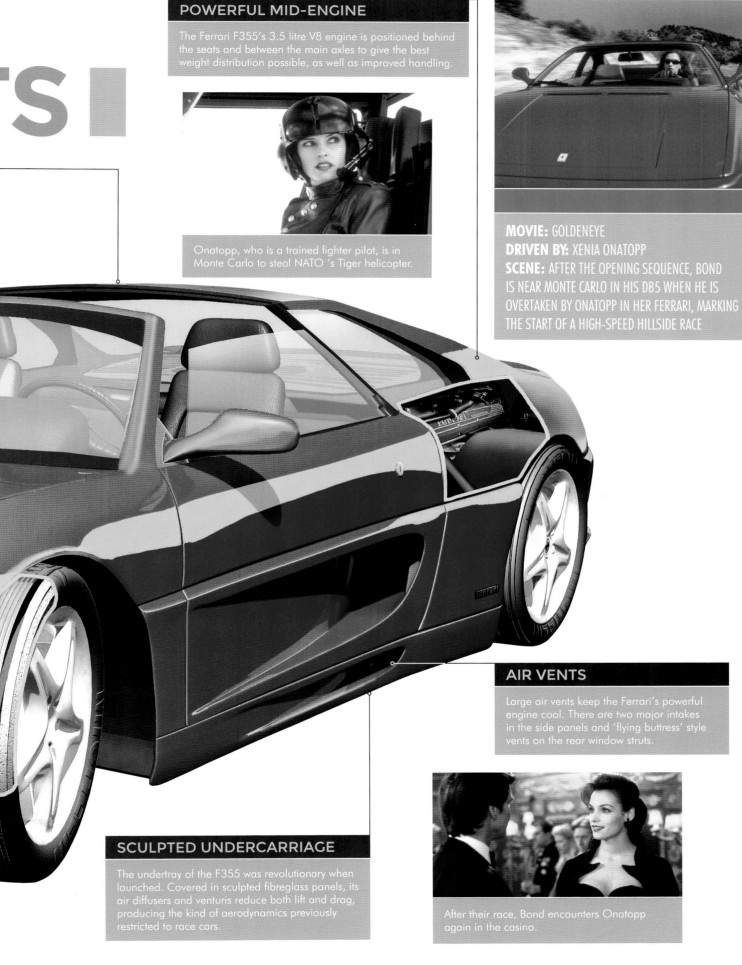

Onatopp, who is a trained fighter pilot, is in Monte Carlo to steal NATO 's Tiger helicopter.

MOVIE: GOLDENEYE
DRIVEN BY: XENIA ONATOPP
SCENE: AFTER THE OPENING SEQUENCE, BOND IS NEAR MONTE CARLO IN HIS DB5 WHEN HE IS OVERTAKEN BY ONATOPP IN HER FERRARI, MARKING THE START OF A HIGH-SPEED HILLSIDE RACE

AIR VENTS

Large air vents keep the Ferrari's powerful engine cool. There are two major intakes in the side panels and 'flying buttress' style vents on the rear window struts.

After their race, Bond encounters Onatopp again in the casino.

SCULPTED UNDERCARRIAGE

The undertray of the F355 was revolutionary when launched. Covered in sculpted fibreglass panels, its air diffusers and venturis reduce both lift and drag, producing the kind of aerodynamics previously restricted to race cars.

JAGUAR XKR

Zao's Jaguar XKR is an arsenal on wheels and proves to be a formidable rival to Bond's Aston Martin V12 Vanquish in a chase on the frozen lake in Iceland.

WHEN BOND ESCAPES his captor Zao in the Ice Palace, they both take to their vehicles for a high-speed chase across the frozen lake. Xao's green Jaguar XKR combines Formula 1 technology with phenomenal military hardware. The XKR has a seemingly inexhaustible supply of weapons and the chase is explosive, with neither gaining the upper hand.

The drivers enter the Ice Palace and 007 tricks Zao into crashing his car over the edge of a balcony, breaking the ice in the process. Zao emerges from the sinking Jaguar XKR, but Bond fires a single shot to sever a cable holding a giant ice chandelier, which falls and impales the terrorist.

Launched in 1998, the XKR had a supercharged version of the engine found in the XK8. In *Die Another Day*, no fewer than eight XKRS were used.

MINI GUN

An electronically controlled miniature Gatling gun rises into position behind the driving seat, fires over the windscreen and retracts. It can rotate through 360° to hit targets in every direction.

MORTARS AND ROCKET LAUNCHERS

The boot compartment is armed for attacks on long-range targets. The boot opens smoothly to fire nine high-explosive aerial bombs. The lower sections of the door panels on each side drop down to reveal three guided Sidewinder missiles.

Zao uses his rear mortars to launch an assault on Bond's Aston Martin. Zao and Bond trade gunfire, with one of Zao's missiles flipping 007's Vanquish and a second narrowly missing the car.

104

The XKR's thermal imaging system allows Zao to track the Vanquish even when Bond has activated his car's 'adaptive camouflage'. Control buttons for the XKR's miniature gun, missiles, radar, armour, mortars and rams are positioned around the imaging display screen.

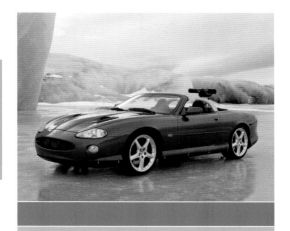

MOVIE: DIE ANOTHER DAY
DRIVEN BY: ZAO
SCENE: JUST AS HEAVILY EQUIPPED AS A BOND VEHICLE, ZAO'S JAGUAR IS A FORMIDABLE FOE FOR 007, CHASING HIS ASTON MARTIN ACROSS A FROZEN LAKE AND THROUGH THE ICE PALACE

Zao is a North Korean agent working for billionaire industrialist Gustav Graves.

RAMMING PRONGS

Two steel spikes, each around one metre in length, extend from the front grille for use as battering rams.

WHEELS

Alloy wheels are upgraded with snow-chain tyre grips. The metal grating and bands of spikes give the Jaguar the necessary traction to traverse ice at speed.

Eighteen unguided mini missiles fire from behind the retractable front radiator grille.

ZiL-117

A gleaming, Soviet-era sedan – a design that debuted in the early 1970s – secured a cameo role in *Casino Royale*, thanks largely to its cavernous boot.

Le Chiffre is at the Casino Royale in a desperate attempt to recoup money after Bond thwarts his plans.

AFTER BOND HAS DISPATCHED OBANNO and his bodyguard in a hand-to-hand fight, field agent René Mathis is tasked with disposing of the bodies. Mathis cunningly arranges for them to be placed in the boot of a Russian ZiL-117 in the hotel car park. This imposing car belongs to Leo, one of Le Chiffre's bodyguards, so when the local police are tipped off about the bodies, not only is the unfortunate henchman arrested, but it also distracts Le Chiffre from the card tournament as he contemplates who would have the power to do this. As Mathis says, 'Being dead doesn't mean one can't still be helpful.'

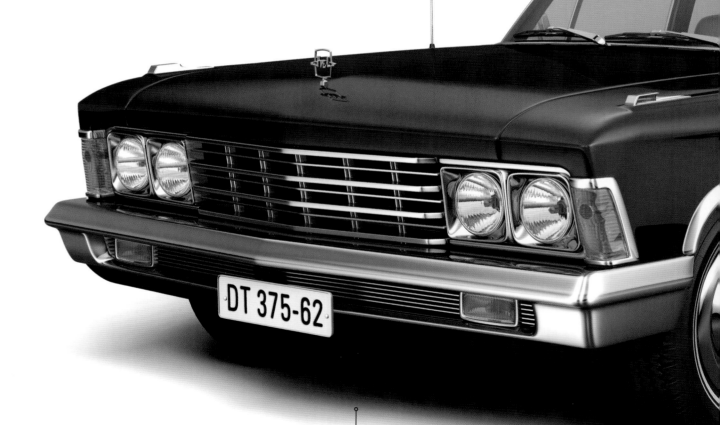

DT 375-62

ROAD PRESENCE

ZiLs were almost always painted black. They were also the biggest, fastest cars in the pre-glasnost era of the Soviet Union and presented an imposing sight.

HIGH-GRADE FUEL

The large 26.5-gallon petrol tank had to be filled with special high-octane petrol as it would not run very well on the normal unrefined fuel used by other Soviet cars.

SMALLER MODEL

This is a five-seat saloon with soft velvet upholstery. Its design was based on the larger seven-seat 114 that had started production a few years earlier in 1967.

MOVIE: CASINO ROYALE
DRIVEN BY: LEO
SCENE: AS BOND AND MATHIS WATCH FROM A BALCONY, POLICE ARREST LEO, HAVING REVEALED THE BODIES OF OBANNO AND HIS ACCOMPLICE IN THE BOOT OF HIS ZiL-117

The game continues at the casino after henchman Leo's arrest.

TOP QUALITY

The build quality was exceptional as these cars went only to the most important people in the Soviet Union, and were expected to work perfectly. They also came with a long list of luxury equipment, including electric windows and seats, air-conditioning and vacuum door locks.

PRACTICAL DESIGN

Like all ZiLs, the 117 has a simple design with very straight lines and no embellishments, taking 'box-car' styling to its most extreme. This makes it very practical, with plenty of space for passengers. However, it also gives it an austere, almost stately appearance.

Mathis is 007's contact in Montenegro. Bond later wrongly suspects him of being a traitor.

ALFA ROMEO 1

Two luxurious 159s are the vehicle of choice for Quantum assassins hell-bent on running down Bond in his Aston Martin DBS, weaving around traffic, hairpin bends and earth-moving machinery.

QUANTUM OF SOLACE opens with a murderous car chase through the mountain roads around Italy's Lake Garda and up into the precipitous dirt tracks of the Carrara marble quarry. Assassins in two black 159s pursue and fire at Bond, who has the Quantum agent Mr. White captive in the boot of his Aston Martin DBS. He is en route to Siena and an MI6 safe house. One Alfa Romeo crashes head-on into a truck; the other, under fire from Bond's Heckler & Koch, spins over the mountainside.

The Alfa Romeo 159 was unveiled at the Geneva Motor Show in 2005. Larger and roomier than its predecessor the 156, it had received modifications to lighten its weight by 2008, the year of its casting in a Bond film. The 159 Limited Edition sedan was only available in the UK at the time of the movie's release.

After Bond's lover Vesper dies, he discovers a message from her that leads him to Mr. White, whom he takes captive.

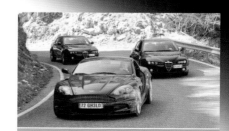

Bond bundles White into his DBS and heads to Siena, but he is instantly pursued by two Alfa Romeos.

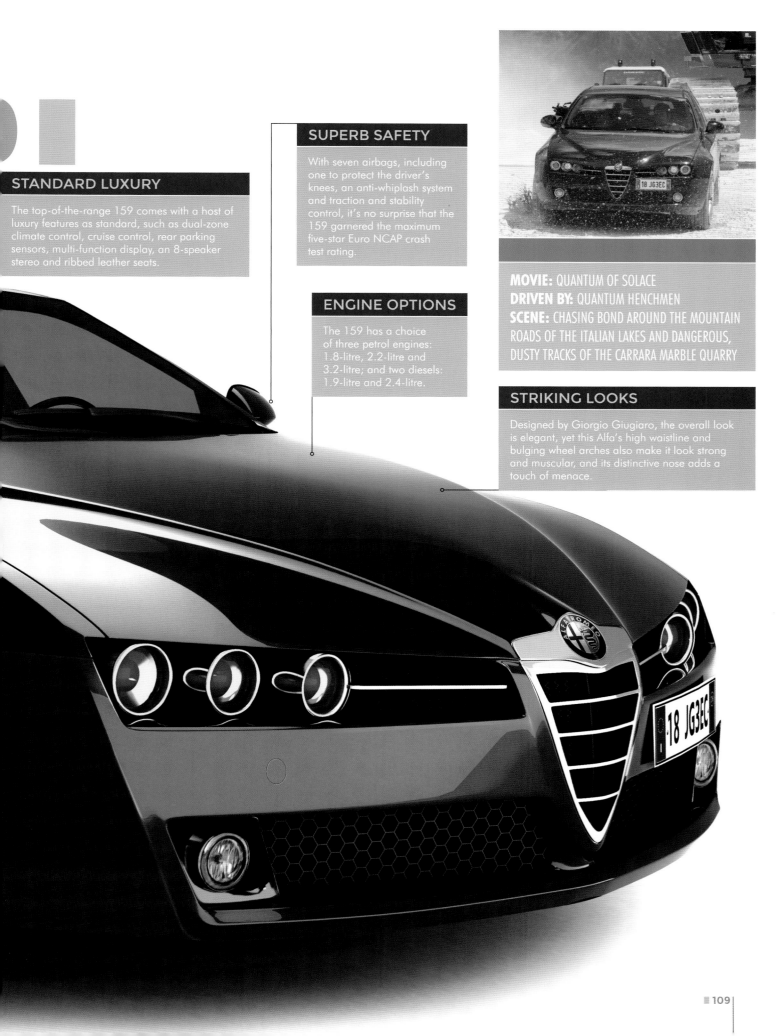

STANDARD LUXURY

The top-of-the-range 159 comes with a host of luxury features as standard, such as dual-zone climate control, cruise control, rear parking sensors, multi-function display, an 8-speaker stereo and ribbed leather seats.

SUPERB SAFETY

With seven airbags, including one to protect the driver's knees, an anti-whiplash system and traction and stability control, it's no surprise that the 159 garnered the maximum five-star Euro NCAP crash test rating.

ENGINE OPTIONS

The 159 has a choice of three petrol engines: 1.8-litre, 2.2-litre and 3.2-litre; and two diesels: 1.9-litre and 2.4-litre.

MOVIE: QUANTUM OF SOLACE
DRIVEN BY: QUANTUM HENCHMEN
SCENE: CHASING BOND AROUND THE MOUNTAIN ROADS OF THE ITALIAN LAKES AND DANGEROUS, DUSTY TRACKS OF THE CARRARA MARBLE QUARRY

STRIKING LOOKS

Designed by Giorgio Giugiaro, the overall look is elegant, yet this Alfa's high waistline and bulging wheel arches also make it look strong and muscular, and its distinctive nose adds a touch of menace.

JAGUAR C-X75

The hybrid show car built to celebrate 75 years of Jaguar made a spectacular guest appearance in *Spectre* – pursuing Bond's DB10 into the River Tiber – and was the only time the public would see its supercar performance for real.

BOND INFILTRATES A SPECTRE MEETING IN ROME convened to elect a replacement for the terrorist Marco Sciarra, whom he has killed. His presence is revealed and a night-time chase ensues through narrow streets, around Vatican City and along the Tiber, with the brutal Mr. Hinx at the wheel of the prototype C-X75. Both supercars exceed speeds of 100mph, and drive down 68 steps of the Scalo de Pinedo to the riverside.

The C-X75 concept car, developed with Williams Advanced Engineering of Formula 1 fame, debuted in 2010 at the Paris Motor Show.

BODY

Each stunt car was built around a tubular space frame chassis with composite body panels. The tubing was very thick for maximum protection.

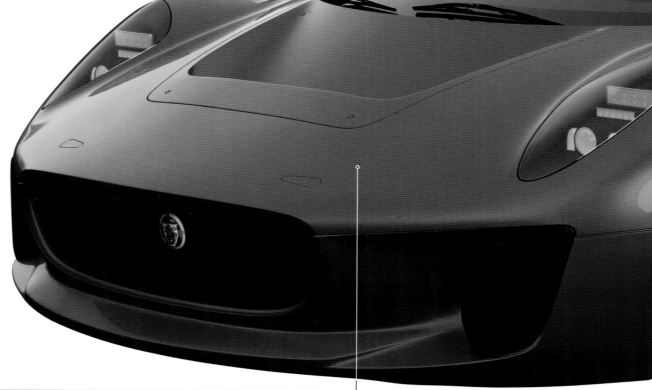

Mr. Hinx is a silent killer, one of SPECTRE's most terrifying agents. Although he misses Bond in Italy, the two meet again in the Austrian Alps and on a train in Morocco, where a grim fight takes place. Hinx utters his one line in the film – an expletive – as he is dragged from the train by a string of barrels.

ENGINE

The stunt C-X75 was fitted with a simpler and less costly 5-litre supercharged V8 engine from the F-type. Its eight-speed automatic gearbox was too long for the C-X75, so they used the same transmission as in a McLaren 650S GT3 competition car.

BRAKES

ABS and traction control were removed and hydraulic brakes added for the most dramatic handbrake turns.

STUNT CAR

The existing C-X75 prototypes, with their lined cabins and highly finished exteriors, were far too valuable to use for anything other than static or slow shots. Therefore, models were built and adapted to handle extreme stunt sequences, such as sudden handbrake turns and jumping.

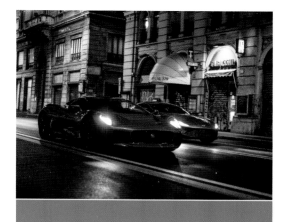

MOVIE: SPECTRE
DRIVEN BY: MR. HINX
SCENE: BOND'S ASTON MARTIN DB10 IS CHASED BY MR. HINX'S JAGUAR C-X75 THROUGH THE NARROW STREETS OF ROME, AFTER 007 IS CAUGHT SPYING ON A SPECTRE MEETING

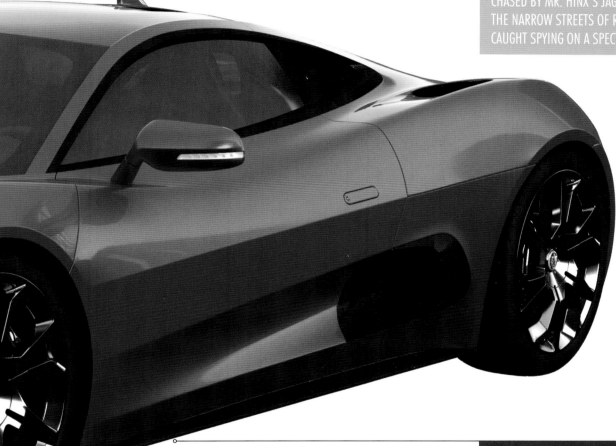

SUSPENSION

The suspension was lengthened and used the same springs and dampers as a rally car. This softened the landing from jumps.

TOP SPEED

Jaguar wanted to rival the Bugatti Veyron for speed. The first prototype exceeded 200mph. Its acceleration was 0–60mph in less than three seconds and 0–100mph in less than six seconds, thanks to the 7-speed automated manual transmission that enabled gearshifts in under 200 milliseconds.

Hinx loses track of Bond after 007 blocks his view with a flamethrower and uses the ejector seat to exit the DBS before it crashes into the Tiber.

General Editor Ben Robinson
Project Manager Jo Bourne
Jacket Designer Stephen Scanlan
Designer Katy Everett
Editors Ian Chaddock, Alice Peebles
With thanks to John Ainsworth, Paul Chamberlain, Ed Giddings, James King, Will Lawrence, Paul Southcombe, Dan White and Colin Williams

EON Productions Jennifer McMurrie, Meg Simmonds, Debi Berry

ISBN 978-1-85875-609-7

Printed in China